THE
VICTORIOUS YOUTH

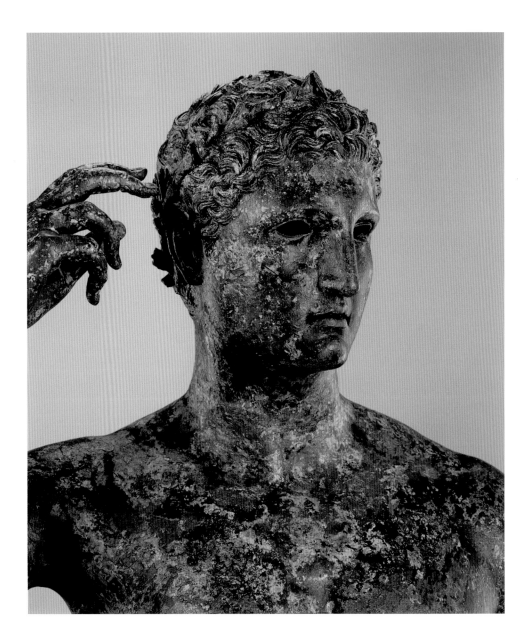

THE
VICTORIOUS YOUTH

Carol C. Mattusch

**GETTY MUSEUM
STUDIES ON ART**

LOS ANGELES

Christopher Hudson, *Publisher*
Mark Greenberg, *Managing Editor*

Benedicte Gilman, *Editor*
Elizabeth Burke Kahn, *Production Coordinator*
Pamela Patrusky Mass, *Designer*
Ellen Rosenbery, Jack Ross, *Photographers*
David Fuller, *Cartographer*

© 1997 The J. Paul Getty Museum
1200 Getty Center Drive, Suite 1000
Los Angeles, California 90049-1687

Library of Congress
Cataloging-in-Publication Data

Mattusch, Carol C.
 The victorious youth / Carol C. Mattusch
 p. cm. — (Getty Museum studies on art)
 Includes bibliographical references.
 ISBN 0-89236-470-X
 1. Getty bronze (Statue) 2. Bronze sculpture,
 Greek—Expertising. 3. Bronze sculpture,
 Greek—Rome. 4. Bronze sculpture —
 Collectors and collecting—Rome. I. Title.
 II. Series.
 NB140.M39 1997
 733'.3 — dc21 97-6758
 CIP

Frontispiece:
Statue of a Victorious Youth [detail],
probably third—second century B.C.
Bronze with copper inlays,
height 151.5 cm (59⅝ in.)
Malibu, J. Paul Getty Museum (77.AB.30)

All works are reproduced
(and photographs provided)
courtesy of the owners, unless otherwise indicated.

Typography by G&S Typesetters, Inc.,
Austin, Texas
Printed in Hong Kong by Imago

CONTENTS

Final page folds out,
providing a reference color plate of
the statue of a Victorious Youth

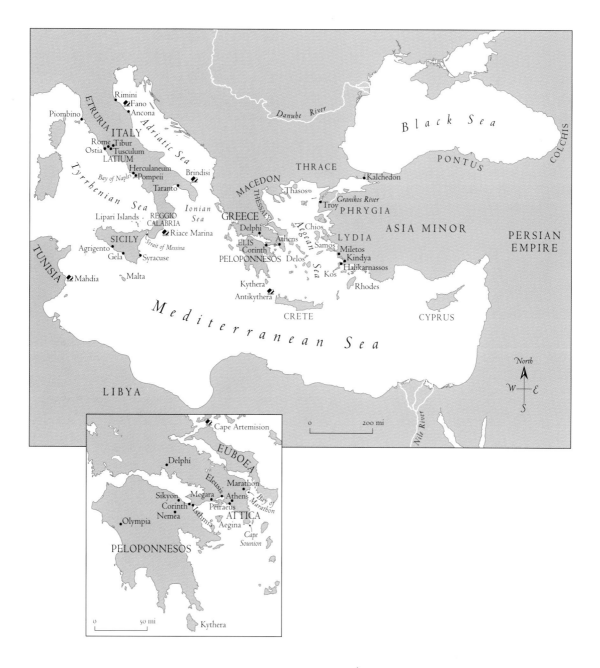

Rimini
Fano
Ancona
Piombino
ETRURIA
ITALY
Adriatic Sea
Rome Tibur
Tusculum
Ostia
LATIUM
Tyrrhenian Sea
Bay of Naples
Herculaneum
Pompeii
Taranto
Brindisi
Danube River
Black Sea
PONTUS
COLCHIS
THRACE
MACEDON
THESSALY
Thasos
Granikos River
Troy
Kalchedon
PHRYGIA
GREECE
Delphi
Chios
Lipari Islands
REGGIO CALABRIA
Ionian Sea
Riace Marina
Aegean Sea
LYDIA
ASIA MINOR
PERSIAN EMPIRE
SICILY
Strait of Messina
Athens
ELIS
Corinth
PELOPONNESOS
Delos
Samos
Miletos
Kindya
Halikarnassos
Kos
Rhodes
Agrigento
Gela
Syracuse
TUNISIA
Mahdia
Malta
Kythera
Antikythera
CRETE
CYPRUS

Mediterranean Sea

LIBYA

North
W E
S

0 200 mi

Nile River

Cape Artemision
EUBOEA
Delphi
Marathon
Eleusis
Sikyon Megara
Athens
Bay of Marathon
Corinth Peiraeus
Nemea Isthmia
ATTICA
Olympia
Aegina
PELOPONNESOS
Cape Sounion

0 50 mi

Kythera

INTRODUCTION

In the world of classical art and archaeology, the J. Paul Getty Museum's life-size bronze statue of a nude youth is well known, both as the continuing subject of scholarly investigations, and as an illustration in handbooks on ancient art [FIGURE 1]. The so-called Victorious Youth, or Getty bronze, represents a handsome young man with a sleek and graceful body, standing at ease, one hip elegantly cocked. His head held high, his expression detached, he raises one hand toward the olive wreath on his head. Most scholars describe the statue as an original Greek bronze and believe that it commemorates a victorious athlete in the ancient Olympic Games. In contrast, many nonspecialists cannot read the expression on the face, do not notice the wreath, and are mystified by the young man's gesture. They wonder why his eyes are blank, why he has no feet, and why he is naked.

The statue was found in the Adriatic Sea, where it had been lost while in transit in antiquity. It was not new when it was shipped: it had once been installed, and it may have been when it was taken off its original stone base that it broke at the ankles. The inserted eyes might already have fallen out by that time. When new, the statue probably stood in a city or a sanctuary.

This study of the Victorious Youth will not be conducted in the traditional manner. Instead, we shall investigate the statue from new vantage points. Its technology will help us discover to what extent the statue may be an "original." Other finds from the sea, as well as ancient literary testimonia, give clues as to the destination of the statue when it was lost at sea. The clay core inside it may even suggest where it was made and when. The varied comments and questions of archaeologists, conservators and conservation scientists, art historians, college students, museum visitors, artists, and medical doctors lead us in directions that have not before been followed in the study of classical statuary. We may never find out precisely who made this bronze, or when, or whom it represents, but each new kind of investigation contributes to the dialogue and may well lead to a new and unexpected discovery. We shall pose questions, even if we cannot yet answer them. New approaches such as these can just as easily apply to the entire field of classical statuary as to the Victorious Youth.

The ancient Mediterranean world. Inset: Peloponnesos and Attica. ❧ indicates shipwrecks.

I

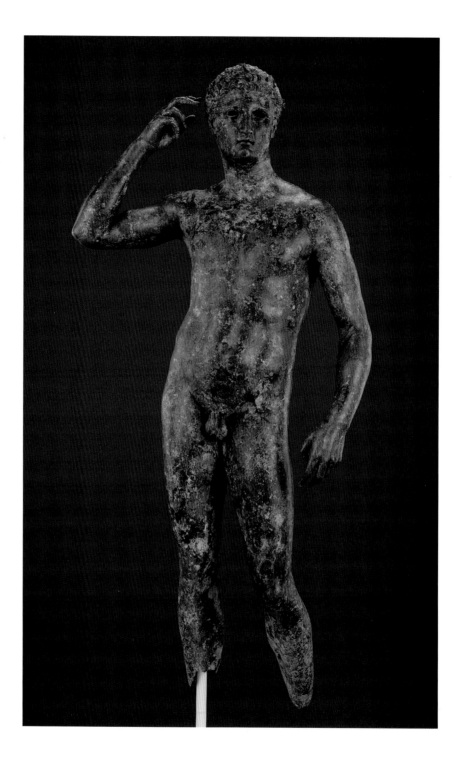

Rescued from the Sea:
Shipwrecks and Chance Finds

Many of the best-preserved classical bronze statues have come to us from the sea, where conditions seem to be more favorable for the preservation of bronze than they are on land. Statues found in the sea are those that were being transported in antiquity, either whole or in pieces. Some were new at the time, made in one place for delivery to wealthy buyers in another part of the Mediterranean world, most often Italy. Others were already antiques, many of them picked up from cities and sanctuaries in the Greek world for delivery to private homes in Italy. Fragmentary statues from the sea appear to be from shipments of scrap metal.

Sometimes cargo was thrown overboard to lighten a ship's load during a storm so that the whole ship would not go down. Later, fishermen might recover bits of the cargo, or even the remains of a whole ship. Occasionally, a bronze statue is brought up. If currents had buried most of the statue in sand, it might be in excellent condition; otherwise, it might be covered with marine organisms that had attached themselves to its hard surface. The Victorious Youth, which was an isolated find from the sea, falls into the latter category. An early photograph of the statue shows such heavy incrustation that the bronze surface was entirely obscured: our attention is drawn to the bit of seaweed dangling between the statue's thighs [FIGURE 2]. All that can be ascertained about the statue itself in this condition is that the figure is male, life-size, and nude, and that the ankles and feet and the inlaid eyes are missing, as is an object once held in the left hand and arm. The graceful young man beneath the marine life and the calcification is virtually unrecognizable.

Whenever a bronze statue is hoisted from the sea, it causes great excitement, for such a discovery is a rare event and is almost always unexpected. Despite the paucity of underwater finds, even today, Willard Bascom, a pioneer of underwater archaeology, has estimated that about twenty thousand ships sank in the Mediterranean world and the Black Sea during the first millennium B.C. Why have relatively few ancient shipwrecks been discovered, and even fewer carefully explored? Wrecks, like individual drowned statues, are usually discovered by chance, often by fishermen or sponge divers.

Figure 1
Statue of a Victorious
Youth, probably third–
second century B.C.
Bronze with copper
inlays, height 151.5 cm
(59⅝ in.). Malibu,
J. Paul Getty Museum
(77.AB.30).

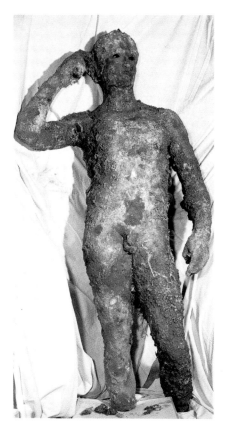

Figure 2
The Victorious Youth, found in the sea during the early 1960s, with seaweed still adhering before cleaning.

Figure 3
Herakles of Farnese type. From the Antikythera shipwreck (about 80–50 B.C.). Found in 1900. Marble, height with base 2.62 m (103⅛ in.). Athens, National Archaeological Museum (5742). Photo: Author.

During the nineteenth century, the best divers in the Aegean Sea could descend to a depth of only two hundred feet or a little more, but when diving helmets were introduced during the late 1860s, divers began to go much deeper. Today, with underwater vehicles operated by remote control, even the *Titanic* is accessible, at a depth of nearly thirteen thousand feet. But there are still relatively few specialists in underwater archaeology, and the work remains costly and highly specialized.[1] Indeed, most of the classical shipwrecks known today are only partial finds; the Victorious Youth was itself discovered by chance after a storm in the Adriatic Sea during the early 1960s.

All of the ancient statues from the sea share at least one characteristic: they have been found out of their original context. If statues were old at the time of shipment, we cannot hope to be able to learn where they were formerly installed. If new statues were being transferred, they raise similar questions. Where were they made? Had they already been purchased? Were they bound for a city center, a sanctuary, or for an aristocrat's garden? It is helpful to examine the nature and range of undersea discoveries before studying the Getty bronze statue more closely.

ANTIKYTHERA

The island of Antikythera lies midway between the Peloponnesos and Crete, south of Kythera, an island sacred to the goddess Aphrodite. In the autumn of 1900, during the prime years of the sponge-diving industry, a sponge fisherman surfaced after a dive to about two hundred feet, reporting "a heap of dead naked women, rotting and syphilitic . . . horses . . . green corpses."[2] He had discovered the so-called Antikythera shipwreck, and what he had seen were not corpses, but marble and bronze statues. When the ship went down sometime between 80 and 50 B.C., it was probably on its way from somewhere in the Greek world to Rome or southern Italy. Its point of origin is unknown, but coins found on the ship suggest that it had set sail in Asia Minor, perhaps at Pergamon.[3]

The date of the wreck has been estimated by the stamped commercial amphorae found on board, by the Hellenistic and Roman pottery, and also by coins and by a number of glass vessels. The dates assigned to the assorted marble and bronze sculptures range from the fourth century B.C. to approximately 100 B.C. Many of these bits and pieces could have come from statues that were removed from their original locations. In fact, eight bronze feet from the wreck were filled with lead tenons, indicating that they had been installed on bases (see p. 23). These then were old, but some of the other works on board, particularly the marble sculptures, were probably new.

Besides large-scale bronzes, the ship's cargo included bronze statuettes, decorative bronze attachments for furniture, and marble sculpture. Scholars have dated the sculptures by style, but most of the marbles are of types that were widely popular throughout the Graeco-Roman period. Despite defacement by salt water and marine organisms, the marbles are still easily recognizable. There is a Herakles of Farnese type, the prototype of which is usually attributed to the fourth-century-B.C.

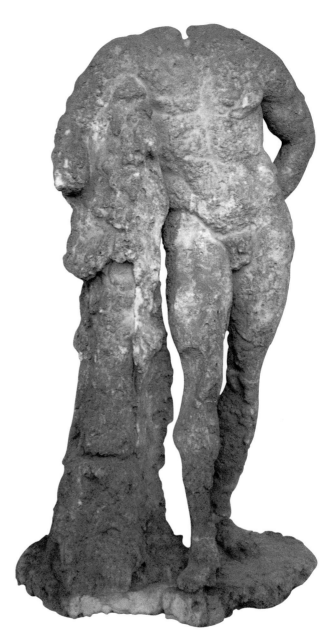

Greek sculptor Lysippos, who evidently had a particular fondness for large and heavily muscled images of Herakles [FIGURE 3]. Indeed, the Antikythera image of Herakles resting on his club, his labors completed, is of a type that has been found in all sizes

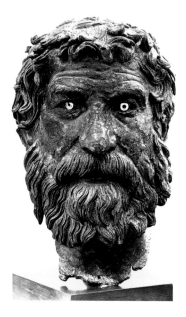

Figure 4
Life-size head of an older man. From the Antikythera shipwreck (about 80–50 B.C.). Found in 1900. Bronze, height 29 cm (11½ in.). Athens, National Archaeological Museum (13.400). Photo courtesy of Deutsches Archäologisches Institut (DAI), Athens, neg. no. N.M. 6065.

and scales and in various media at places throughout the Graeco-Roman world. Its popularity lasted until late antiquity, when the imperial Baths of Caracalla in Rome contained two marble statues of this type.

In addition to the Herakles, the marble statuary on the Antikythera ship included two common types of Aphrodites, two of Hermes, as well as Zeus, Apollo, Achilles, Odysseus, and an oil pourer. Not so easy to place are the torsos of youths (athletes or young gods?), a helmeted man, two mature seated figures (probably portraits of important men), dancers, and horses. It is clear that a good number of these marbles were from popular production lines, and we can surmise that the merchandise was for private consumption.

The life-size bronzes in the cargo were not all new productions, and their fragmentary condition suggests that at least some of them were not complete when they were loaded into the ship. Could there have been some scrap metal in the cargo? The head of an elderly bearded man seems to match a pair of arms and two sandaled feet [FIGURE 4]. But there are also another right arm and hand, a right hand, two left hands, a left arm, a left arm and hand wearing a boxing glove, six more feet, four pieces of drapery, two swords, and a lyre.

A life-size bronze statue of a powerful young nude may depict an athlete [FIGURE 5]. Although this is the most complete of any of the sculptures from the shipwreck, it too was found in fragmentary condition, missing the base of the neck, a large area above the hips, and part of the left thigh. The original surface is irretrievably lost. The statue was very difficult to piece back together, and more than one attempt has been made at restoration. Can we be certain that the position as now restored is absolutely correct?

Scholars have never been able to agree about who this young man is or what he is doing. He has been called Paris extending a golden apple in his right hand, or Perseus holding up the head of Medusa. Most frequently, he is identified as an athlete. If so, was he throwing a ball? More relevant to our inquiry, can this be a statue of a victor despite the fact that he wears no wreath? The large and imposing image is usually dated to the third quarter of the fourth century B.C., on stylistic grounds, some three centuries before the date of the shipwreck.

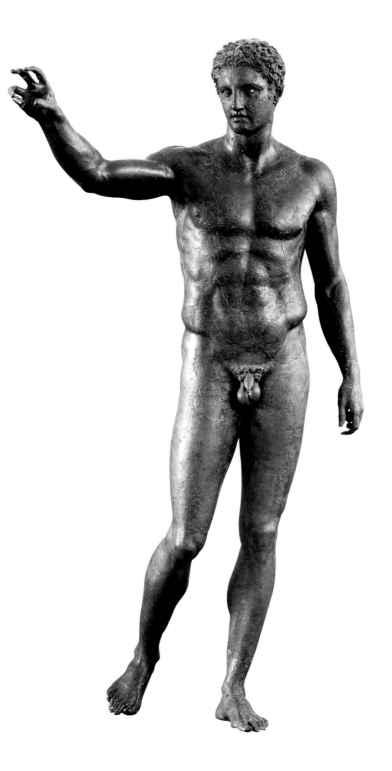

Figure 5
Large statue of a youth.
From the Antikythera
shipwreck (about 80–
50 B.C.). Found in 1900.
Bronze, height 1.96 m
(77 ⅛ in.). Athens,
National Archaeological
Museum (13396). Photo
courtesy of DAI, Athens,
neg. no. N.M. 5357a.

Another ship carrying marbles and bronzes went down during the second quarter of the first century B.C. off the coast of what is now Tunisia. The discovery of the wreck was first reported on June 21, 1907, when Alfred Merlin, the director of antiquities for Tunisia (a French protectorate at the time), sent the following telegram to his superiors in Paris: "After inspection of the objects, [Louis] Drappier confirms this morning from Mahdia the discovery under water of statues of a youth, a Priapus, a Bacchus, and of architectural fragments, all of bronze."

The finders were again Greek sponge divers. They had made their discovery about 5 km off the coast of Tunisia, at the seaport of Mahdia, in water more than 130 feet deep. Since 1907, a dozen underwater campaigns have been undertaken at the site.

The huge ship with its vast cargo of luxury items sank near Mahdia between 90 and 60 B.C. The masted vessel was more than 40 m long and nearly 14 m wide. Its cargo shows that it may have been to Tunisia, Spain, Italy, the Peiraeus, and the island of Kos, and probably also Delos and Rhodes, to judge from the utilitarian objects on board—transport amphorae, lead ingots, pottery, terracotta lamps, and a few coins. When the ship wrecked, it was evidently on its way from a Greek port to southern Italy or to Rome's port city of Ostia. The captain may have charted a course around Sicily in an attempt to avoid the treacherous waters of the Strait of Messina.

The cargo was far more extensive than was first reported and included both new and old objects. There were marbles—kraters (vessels for mixing wine and water), and candelabra, statuary, busts, reliefs, column capitals and bases, and sixty to seventy marble column shafts. And there were bronzes—both statuary and furnishings. There was a statue of a winged Eros, a herm of Dionysos, and large statuettes of a winged Eros playing a lyre, three dancing dwarves on round bases, a satyr, an actor, and a Hermes on a rectangular base. Two hanging lamps in the form of hermaphroditic figures had the tops of their heads hinged for receiving oil. There were other lamps, a brazier, bronze vessels, a large standing mirror, a massive bronze rudder ornament, and the bronze legs and decorative fittings for more than twenty dining couches.

The two large bronzes—the herm (see p. 65) of Dionysos and the winged Eros—had previously been installed, for both retained the lead tenons that had been used to fix them to their bases. The herm [see FIGURE 46] is signed by Boëthos of

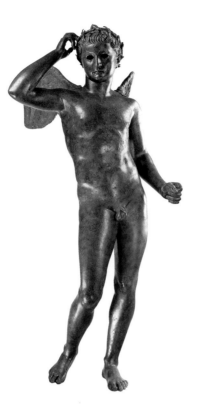

Figure 6
Life-size statue of Eros, perhaps second century B.C. From the Mahdia shipwreck (90–60 B.C.). Found in 1907. Bronze, height about 1.36 m (53½ in.). Tunis, Bardo Museum (F 106). Photo courtesy of Rheinisches Landesmuseum, Bonn. Photo: H. Lilienthal.

Kalchedon, an artist who is known to have worked in the middle of the second century B.C. The Eros [FIGURE 6] is likewise believed to have been made during the second century, but on the basis of its style; it is not inscribed, so it cannot be identified as the work of a specific artist.[4] Eros, however, was a vastly popular subject in Graeco-Roman sculpture, painting, and literature.

Eros was a paradoxical god, a powerful and dangerous deity who inhabited the body of a child. This life-size bronze statue shows him as a child of about twelve, standing casually with his left hip thrust out and his right leg trailing. His delicate childlike wings are spread, and we can imagine him having just come to a gentle landing, a bow and arrow held upright in his left hand. His hair is wavy, a tiny braid curls onto the nape of his neck, and he wears a wreath, which he is fingering in a thoughtful manner. This is unmistakably the wreath of a victor. He is Love Triumphant, but he is so disarming that we might almost forget to mistrust him. The words of Moschos, written in the second century B.C., are a bitter caution:

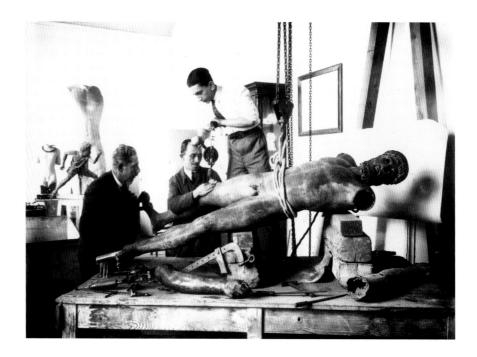

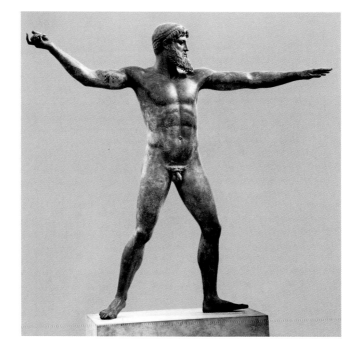

Figure 7
Statue of a god from
Cape Artemision, proba-
bly about 460 B.C. Found
in 1926 and 1928. Dur-
ing restoration. Bronze,
height 2.09 m (82⅛ in.).
Athens, National Archaeo-
logical Museum (15161).
Photo courtesy of Olga
Tzachou-Alexandri.

Figure 8
Statue of a god from
Cape Artemision, proba-
bly about 460 B.C.
Bronze, height 2.09 m
(82⅛ in.). Athens,
National Archaeological
Museum (15161).

Cypris cried loudly her lost son Love. "If anyone hath seen Love straying in the cross-roads, he is my fugitive child. . . . The boy is easily recognisable. . . . Evil is his heart, but sweet his speech, for what he has in his mind he speaks not. His voice is like honey, but if he grow wroth his spirit cannot be tamed. A cozener he is, never speaking the truth; a cunning child, and the games he plays are savage. Plenty of hair on his head, and he has a most forward face. . . . Like a winged bird he flies to one man and woman after another, and perches on their vitals. He has a very small bow, and on the bow an arrow; . . . his kiss is evil and his lips are poison." [5]

ARTEMISION

Bronzes from the sea are often more isolated finds than the spectacular discoveries at Antikythera and Mahdia might suggest. For example, in 1926, a fisherman found a bronze arm in water 140 feet deep off Cape Artemision on the island of Euboea in Greece. Two years later, the rest of the statue was salvaged, in remarkably good condition, despite the fact that both of the arms had broken off below the shoulders at about the point where they had originally been joined to the statue [FIGURE 7].

The larger-than-life-size Artemision God, now in the National Archaeological Museum in Athens, represents Zeus or Poseidon. He is striding forward about to hurl his weapon, either a thunderbolt or a trident [FIGURE 8]. His legs are spread, and his arms are extended, the left one level and forward as he takes his mark, the right one drawn back and poised for the attack. The highly realistic anatomy of this imposing statue represents the artistic culmination of a type that was extraordinarily popular during the Archaic period in Greece (sixth century B.C.), one that was equally well suited for images of gods, heroes, and warriors. Probably cast during the second quarter of the fifth century B.C., the Artemision God is the latest surviving large-scale example of this type of statue. In a direct reference to the familiar Archaic versions of striding, attacking warrior statues, a Roman Republican relief from first-century-B.C. Ostia shows fishermen netting an Archaic Greek statue of Herakles in nearly the same pose [FIGURE 9]. It is fascinating to see that Herakles himself also appears in the relief, standing on the dock while the men pull in their net containing the Archaic statue of himself. But the "real" god is rendered as naturalistically as the fishermen!

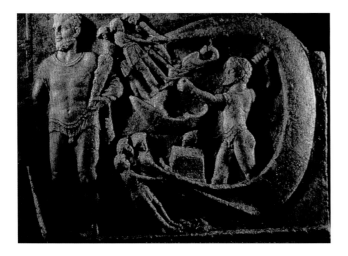

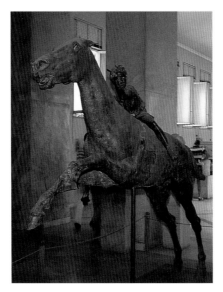

A bronze racehorse was also recovered from the sea at Artemision; the rider and the foreparts of the horse appeared in 1928, and the horse's hindquarters were netted by a fisherman in 1937 [FIGURE 10]. The horse plunges forward, lips drawn back from its teeth, nostrils flaring, ears flattened, both front hooves in the air. On its hindquarters, an outlined Nike holding the victor's wreath aloft was once inlaid like a brand on a real horse. The style of the horse and of its rider, perhaps an African child, indicates that they are of a much later date than the bronze god from the same wreck. Were both bronzes once installed in Greece, then ripped from their bases in order to be carried as antiquities to Rome? Little is known of the wreck itself, or of whether more of its cargo remains to be discovered.[6]

Most of the bronzes that the Roman historian Pliny describes in his *Natural History* (first century A.D.) were old statues that had been transported to Rome. When the Roman consul Mummius devastated Greece in 146 B.C., he looted Corinth and its sanctuaries of their finest works. The Roman general Sulla captured Athens in 86 B.C. and collected objects in that city; Mark Antony looted Greece later in the century; and so did Gaius Verres, who was even more rapacious as governor of Sicily from 73 to 70 B.C., and whom Cicero bitterly critized in his Verrine Orations for acquiring all sorts of statues, among them fifth-century bronzes by the sculptors Myron and Polykleitos (see p. 60).

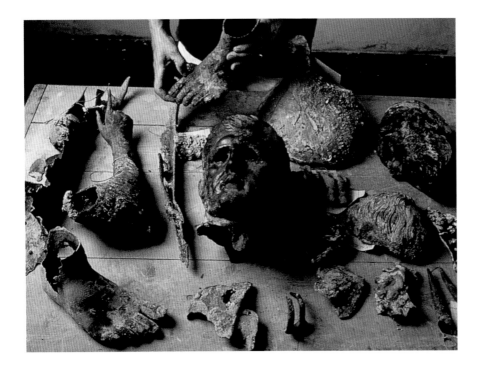

BRINDISI

A great many bronzes were discovered in July 1992, a quarter of a mile off the Italian coast near Brindisi. A policeman who was an amateur diver found the first piece. As soon as he reached out and touched the toes sticking out of the sand fifty feet underwater, he realized that they did not belong to a human body. He reported his find immediately, and teams of archaeologists and underwater experts were called in from Italy's Technical Service for Underwater Archaeology, as well as from a private cooperative of excavators.

This was not a cargo of salable luxury objects, but rather one of scrap bronze [FIGURE 11]. There were bits and pieces from as many as a hundred statues that had clearly been smashed before loading, and that were no doubt to be sold as scrap metal. One hundred and twenty-one pieces have been catalogued, including one relatively complete statue; the head-to-hips of another; twenty-three heads and pieces of heads, arms, hands, feet, wings; and many smaller fragments. One arm was approximately four times life size. From its style, one head has been dated as early as the fourth century B.C., while other portraits are dated as late as the late second or early third

Figure 11
Body parts of bronze statues of various dates. Found in the Adriatic Sea near Brindisi in 1992. Photo: O. Louis Mazzatenta/National Geographic Image Collection, Washington, D.C.

century A.D. There is no real evidence for the ship itself, but fragments of commercial amphorae found with the statues have been dated to the sixth century A.D. The assemblage can thus not be earlier than that last date.

Were the bronzes and amphorae jettisoned during a storm? Were they all picked up in one place? Even if they were not, the scraps of cargo provide a remarkable insight into the array of bronzes of different dates and sizes that would have been on display simultaneously in one or more city centers. They must all have been familiar types of statues, immediately recognizable to a broad spectrum of the general public. Even today we can recognize a powerful young ruler in a hipshot pose; an older man of letters with tousled hair and a long beard; an official wearing a toga; and a few bare feet from nude heroic males, one of them colossal. There are portraits of men and women of the various imperial families, hands with ringed fingers, and two colossal arms, one of them raised in an authoritative gesture with a pointing forefinger. In the end, all were unceremoniously broken up to save space in the ship's hold, and they were sent off to be recycled. By the sixth century A.D., the early Christians had no other use for the weathered public statuary of the classical world.

These shattered scrap bronzes from a post-classical ship make a stark contrast to the revered statues of classical antiquity. Styles and types that were established during the fifth century B.C. for particular classes of public images, such as athletes and heroes, became traditional, and some statues retained their importance for significant periods of time. Thus, the Greek travel writer Pausanias is viewing sculptures produced over a long period of time when he writes in the second century A.D. He need not describe the statue of Theagenes of Thasos, a champion boxer in the Olympic Games of 480 B.C., for everyone would have known what a victor's monument looked like, even at a distance of almost seven centuries.

> When he departed this life, one of those who were his enemies while he lived came every night to the statue of Theagenes and flogged the bronze as though he were ill-treating Theagenes himself. The statue put an end to the outrage by falling on him, but the sons of the dead man prosecuted the statue for murder. So the Thasians dropped the statue to the bottom of the sea, adopting the principle of Draco, who, when he framed for the Athenians laws to deal with homicide, inflicted banishment even on lifeless things, should one of them fall and kill a man. But in course of time, when the earth

yielded no crop to the Thasians, they sent envoys to Delphi, and the god [Apollo] instructed them to receive back the exiles. At this command they received them back, but their restoration brought no remedy of the famine. [They went back to Delphi, and] the Pythian priestess replied to them:—

"But you have forgotten your great Theagenes."

And when they could not think of a contrivance to recover the statue of Theagenes, fishermen, they say, after putting out to sea for a catch of fish caught the statue in their net and brought it back to land. The Thasians set it up in its original position, and are wont to sacrifice to him as to a god. (Pausanias 6.11.6–8)

MARATHON

A life-size statue of a *mellephebe* (prepubescent boy) was discovered by fishermen near the beach in the Bay of Marathon in 1925 [FIGURE 12]. Nothing else was found at the time, and the exact location of the find has apparently long been forgotten. In 1976, a French-Greek underwater team examined the area, but their search did not reveal a ship.[7]

The Marathon Boy's features are delicate, and the pensive gaze is still enhanced by inset eyes. As preserved, the statue is missing only the separately cast front of the right foot, a piece of the left heel, and the objects that he once held, which could have helped us understand the statue. The positions of the arms are awkward now, without the attributes, and there is no real evidence as to what is missing. In the same way, the Getty bronze's gestures are ambiguous now, because the fingers of the right hand do not quite reach the broken leaves of the wreath, and the attribute that he once cradled in his left arm is gone.

The Marathon Boy is engaged in an activity that has always mystified scholars. He is looking at some object with a flat resting surface that was pinned to the upraised open palm of his left hand. The boy extends his right arm delicately upward as if he were holding something that was linked to his left palm. Was he pulling a long ribbon from a container, or preparing to pour from one vessel into another? Maybe the boy was holding out his diskos. A clue to his identity is the headband, adorned with a curving leaflike ornament at the top of his head. Athletes represented in sixth- and fifth-century-B.C. vase-painting often wear such headbands, as do a few sculptures of youths made about the same time or somewhat later. Indeed,

the style of the Marathon Boy has suggested to most scholars a production date in the latter half of the fourth century B.C.

Can this boy even be an athlete, let alone a victor? His muscles are soft and undeveloped. Would a statue like this have stood in a *palaestra* (gymnasium), or somewhere else? It has been proposed that the statue came from the second-century-A.D. villa of Herodes Atticus near the Bay of Marathon. A wealthy and philanthropic Athenian with impeccable taste in sculpture, Herodes Atticus had many friends in Rome, among them the emperors Hadrian, Antoninus Pius, Marcus Aurelius, and Lucius Verus. It is tempting to think that a statue such as the Marathon Boy might have been an antique in his collection.

Or was this statue holding a tray that could be stocked with delicacies, or a pitcher and a bowl? We know that utilitarian but also somewhat sensuous statues of this kind were popular in Roman houses. Much earlier, in fact, by the early fifth century B.C., nude boys were frequently shown in the company of mature men. We see them in vase-paintings as servants, musicians, apprentices, and lovers. Plato writes of the comfort and amusement that these handsome boys provided to their men-friends, gleaning some wisdom in return. Can the statue from the Bay of Marathon have recalled such a context?

Figure 12
Boy from the Bay of Marathon. Found in 1925. Bronze, height 1.3 m (51⅛ in.). Athens, National Archaeological Museum (15118). Photo courtesy of DAI, Athens, neg. no. HEGE 855.

RIACE

Although Greek athletes competed in the nude, their representation in sculpture and painting might better be read as a heroization, separating them from ordinary mortals. Nudity is a standard feature of certain types of images of gods and heroes—the striding attacking god, for instance; or Eros triumphant; or the standing warrior. Whether the last is a god or a man, the body is always of heroic proportions and of unquestionable physical strength. Pliny explains why: "Naked figures holding spears, made from models of Greek young men from the gymnasiums—what are called figures of Achilles—became popular. The Greek practice is to leave the figure entirely nude, whereas Roman and military statuary adds a breastplate" (34.10.18).[8]

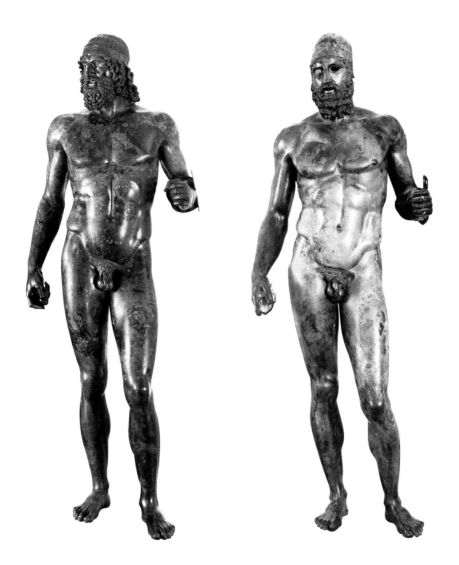

The so-called Riace Bronzes are of the classical fifth-century style, men of commanding presence and of action [FIGURES 13, 14]. They are physically strong, but they are not athletes. Both once carried spears in their right hands and wore shields on their left arms and helmets on their heads. Otherwise, they are nude, their peak physical condition and graceful relaxed stance indicative of their prowess and of their right to these commemorative statues. Both bear their weight on the right leg, right hip cocked. Both are bearded, but one has long hair, the other short hair. Any ancient passerby would have been familiar with this type of statue and would have been properly

Figures 13, 14
The Riace Bronzes, probably fifth century B.C. Found in 1972. Bronze, height of statue A, 1.98 m (78 in.), statue B, 1.97 m (77½ in.). Photos courtesy of the Soprintendenza Archeologica della Calabria. Reproduced by permission of the Ministero Beni Culturali e Ambientali.

impressed by the importance of these two individuals. Chances are that, like us, onlookers would not have known precisely who the statues depicted without the help of an inscribed base, which we no longer have today. Like many of the other bronzes from the sea, these two had been erected before they were removed from their bases for shipment: we know this because both of them were found with lead tenons in their feet.

A Roman chemist on vacation at Riace Marina not far from Reggio Calabria found the Riace Bronzes on August 16, 1972. He was diving near the beach, at a depth of about twenty-five feet, when he thought he saw the arm of a corpse sticking out of the sand. He touched it, and realized it was metal, not human flesh. Nearby was the second statue; both were thinly covered by sand and heavily incrusted. He reported the statues to the authorities. Subsequent investigations of the site revealed no specific evidence for a shipwreck, only a number of lead rings (from the rigging of a ship?), a bit of a ship's keel, and a few amphora fragments of widely ranging dates.

The two over-life-size statues caused an immediate sensation. They were given the names of the local saints, Cosmas and Damian. When the statues were hoisted from the sea, where they had been for some two thousand years, they were not only corroded but also incrusted with marine organisms and impregnated with sea salts. Because the statues were badly in need of conservation, they were taken, over the protestations of the local citizens, to the laboratory of the National Museum at Reggio Calabria for cleaning, then sent to the Restoration Center of the Archaeological Museum in Florence in 1975. It was critical to arrest active corrosion and to prevent additional problems from developing as a result of exposure to a new environment. Scalpels and tiny pneumatic drills were used to clean concretions from the bronze surfaces. The statues' clay cores had absorbed lime and sea salts, so they too had to be removed as far as possible, a painstaking process that took two conservators five years to complete. Internal areas that were impossible to reach were treated to prevent further oxidation.[9]

Once cleaned and stabilized, the Riace Bronzes were exhibited in the Archaeological Museum in Florence from December 1980 to June 1981, where six hundred thousand people came to see them. Then they were sent to Rome, where they caused a similar sensation: three hundred thousand people saw them in a space of three weeks. After heated debate, the warriors were installed in the National Museum of Reggio Calabria, where they have stayed despite occasional requests for loans, for

example, by the committee for the 1984 Los Angeles Olympic Games. During their first year in Reggio Calabria, seven hundred thousand people visited the museum.

> I saw some visitors who carried their children in their arms. . . . They told us that they were trying to "feel" the statues through the children. They were, in fact, attempting to establish physical contact with something that seemed in some measure to participate to [sic] the divine dimension, and by so doing, to enter into the world of . . . the holy. . . . As a gesture it is the equivalent of placing the child under divine protection, while it manages to transfer to the child through the actual physical contact a portion of the divine force.[10]

By 1992, the annual number of visitors to the National Museum in Reggio Calabria had dropped to seventy-nine thousand.[11] With a major grant from Finmeccanica, a highly publicized project was initiated in 1992 to arrest possible continuing corrosion of both statues. The project, which lasted for four years, brought the Riace Bronzes renewed attention, surely because the statues remained on public view throughout. Visitors to the museum climbed a stairway to a platform from which they could look down into a specially designed laboratory space. There the statues lay on their backs as if on operating tables, while a team of white-coated technicians probed through the holes in their feet with remote-control endoscopes equipped with video cameras and watched the progress of the cameras on television monitors. This "microexcavation" resulted in the removal of about eighty pounds of clay core material from each statue.

In what city or sanctuary did the Riace Bronzes stand before their fateful journey? The origin of the ship that carried these statues is a tantalizing question that has been much discussed but not resolved. Some argue vehemently for Greece, others are convinced that the bronzes were being shipped from one of the Greek cities of South Italy or Sicily. The fact that no significant traces of a ship were found in the area could mean that the statues were thrown overboard during a storm. Occasionally, rumors have surfaced that the statues were actually discovered by fishermen, not at Riace Marina, but in the Adriatic Sea in the region of Abruzzi e Molise, and that they were towed underwater to Calabria, where attempts to sell them failed. The story ends with the tantalizing allegation that someone in the Abruzzi has the shield that was carried by one of the statues.

The statue of the Victorious Youth was evidently found during the early 1960s at some distance from shore by fishermen from Fano, a resort town on the Adriatic Sea about halfway between Rimini and Ancona. The statue had lost its feet and inlaid eyes but was otherwise complete. Its height today is 151.5 cm (59 5/8 in.). It was heavily incrusted with marine deposits—shells, corals, and mud [see FIGURE 2]. To clean up the statue for sale, someone made rather brutal attempts to scrape away the incrustations and reveal more of the bronze beneath. Scratches on the statue's surface are clear evidence of the damage inflicted by this process [FIGURE 15]. The statue's history over the next ten years is uncertain, for even though the Italian police apparently knew about the bronze by 1965, they were unable to locate it. Men were tried for but acquitted of harboring the statue, and it was exported, although when and to what country remains a mystery.[12]

In 1971, Heinz Herzer, a Munich dealer with the Artemis Group, an international art consortium, acquired the statue, its right arm broken off [FIGURE 16] and the left arm cracked [FIGURE 17]. Restoration and study began immediately. Bits of shell remained on the bronze at that time, as well as some calcareous incrustation. Analysis of the metal revealed a green upper layer of paratacamite, a copper chloride caused by submersion in seawater. Beneath this a thin layer of red copper oxide was revealed.

In 1972, Herzer and Volker Kinnius wrote a report on the conservation of the statue by R. Stapp. According to their document, which was accompanied by photographs, the bronze was cleaned mechanically (by hand). The loose left arm was removed, X-radiographs were taken, and large quantities of the ancient clay core were removed from the statue [FIGURE 18].[13] The bronze was immersed in a heated solution of sodium sesquicarbonate; next it was subjected to vacuum treatment; then the bath was changed to distilled water. During these repeated phases, periodic exposure to high levels of humidity revealed the recurrence of bronze disease (active corrosion). When the bronze had been stabilized, both arms were reattached, and two stainless steel bars were inserted, one reaching from the break in the right leg to the neck, the other across the shoulders and into the upper arms. Unfortunately, the synthetic resin that was used to attach this modern armature inside the neck, shoulders, upper arms, and right knee has rendered all of these areas impervious to X-radiography. Last of all,

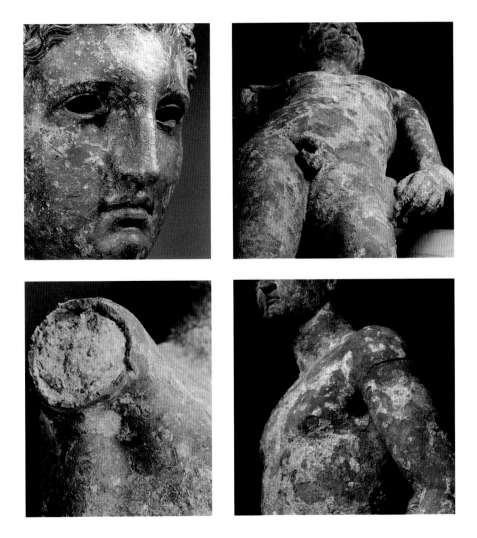

Figures 15–18
The Victorious Youth.
Clockwise from top left:

Detail of face, showing damage inflicted during the first cleaning.

Detail of body before thorough cleaning; right arm removed.

Before first restoration, with crack in left arm, and with left nipple missing.

Before first restoration with right arm broken off, revealing core material inside.

the surface of the statue was sprayed with synthetic resin. The Herzer-Kinnius report ends with observations about the interior surface of the bronze and concludes that the statue was cast by the lost-wax process.

In 1974, a radiocarbon date was obtained from a piece of wood that had come from the statue's core. Essentially all it established was that the bronze was actually ancient. This had never been questioned; on the contrary, the statue was viewed as possibly a work by the fourth-century-B.C. sculptor Lysippos, and it was identified as a victor in the Olympic Games.[14] Some still believe this to be the proper identification.

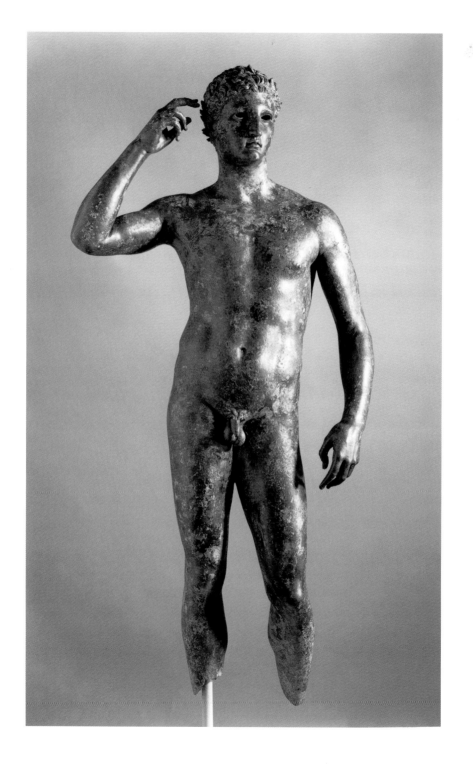

STATUES FOR CIVIC PRIDE

Since fewer than half a dozen extant bronze statues have been discovered in a context that is even close to where they were originally installed, it may be helpful to examine the types of locations in which a figure such as the Getty bronze statue might once have stood, or to which it might have been in transit. These include the cities, sanctuaries, and private homes of the ancient world.

The Victorious Youth had been erected before it was loaded onto a ship for transport across the Adriatic Sea [FIGURE 19]. The feet and ankles were broken off the statue when it was removed from its original stone base. Classical statues were most often installed by means of lead tenons that were poured into the legs through holes in the soles of the feet, or sometimes they were fixed in place by molten lead beddings that were poured beneath the feet. Stone statue bases either have deep cuttings to receive the lead tenons or larger shallow ones for the lead beddings. Traces of lead are often visible on bases missing their statues or inside the feet of statues that have been detached from their bases.

Without its feet, the Getty bronze weighs 48–50 kg (105–110 lbs.), so it would not have been easy for two men to remove the statue from its base.[15] As it is now, the statue illustrates what could happen all too easily if the lead tenons were still holding a statue firmly in place when it was taken down. And yet this statue snapped cleanly off its base, for though the feet were torn off, the legs were not bent, nor was there any other careless mutilation of the bronze. No doubt the ankles had weakened during the time the statue had been standing outdoors, subject to the corrosive powers of rain, frost, and snow.

Thousands of bronze statues were erected outdoors in antiquity, many of them in public places. Anyone walking through a city or a sanctuary would have seen images representing gods and heroes, athletes and philosophers, rulers and statesmen. The ancient literary testimonia provide vivid descriptions of the monuments in the major cities of the Mediterranean world, and they help to establish the context from which the Getty bronze had been removed. Indeed, the second-century-A.D. Greek travel writer Pausanias recorded many of the statues that he saw on his extensive travels

Figure 19
The Victorious Youth in raking light.

23

in Greece as well as a great deal of information about them. His books provide a major source of information about the appearance of an ancient city. Thus he writes about the Athenian Akropolis, "There is . . . a bronze Athena, tithe from the Persians who landed at Marathon. It is the work of Pheidias. . . . The point of the spear of this Athena and the crest of her helmet are visible to those sailing to Athens, as soon as [Cape Sounion] is passed" (1.28.2). We can only guess at how sailors felt upon seeing the tip of the spear of this colossal Athena on the Akropolis, glinting in the sunlight as they sailed toward the Peiraeus [FIGURE 20]. It was a clear signal that soon they would dock.

The Peiraeus had been the major port of Athens from the time when Themistokles was archon in 493/492 B.C. The great city planner Hippodamos of Miletos gave the port city a formal plan in the middle of the fifth century. The Long Walls to Athens, also built in mid-century, secured the Athenians access to the sea and to provisions during the Peloponnesian War. However, the fortifications and the Long Walls were of no help against the siege of the Roman general Sulla in 86 B.C. His battering rams, powered by ten thousand yokes of mules, demolished the walls.

THE PEIRAEUS

One of the casualties of Sulla's attack was a warehouse near the harbor. When it burned down, it was stocked with bronzes and marbles ready for shipment. In 1959, workmen digging a sewer line under a street in the Peiraeus discovered the ancient warehouse. Subsequent excavations revealed four bronze statues, a bronze tragic mask, two bronze shields, two marble herms, and a small marble sculpture of Artemis Kindyas, the local goddess of the city of Kindya in Asia Minor.

An over-life-size bronze statue of Apollo lay on its back with a marble herm on top of it [FIGURE 21]. Next to the Apollo lay a huge bronze Artemis [FIGURE 22], facing in the opposite direction. A second group of objects included a colossal bronze Athena [FIGURE 23], a small bronze Artemis, a marble herm, and a bronze mask. The metal alloy of the four statues is very similar, each with a little lead as well as copper and tin. This suggests that the statues were all made in one workshop. But were they new or old when they reached the warehouse? All four are relatively common types. In general, the statue of Apollo looks Archaic (from the sixth century B.C.), but stylistic anomalies point to a much later date and suggest that it was intended for

Figure 20
Roman coin showing the Bronze Athena on the Akropolis, second century A.D. Bronze, diameter 2.1 cm (⅞ in.), weight 4.39 g. London, The British Museum, registration no. 1922 3-17-82. © British Museum.

Figure 21
Statue of Apollo from a warehouse in the Peiraeus destroyed in the first century B.C. Found in 1959. Bronze, height 1.91 m (75¼ in.). Peiraeus Museum. Photo courtesy of the Ministry of Culture, Archaeological Receipts Fund, Athens.

Figure 22
Statue of Artemis from a warehouse in the Peiraeus destroyed in the first century B.C. Found in 1959. Bronze, height 1.94 m (76⅜ in.). Peiraeus Museum. Photo courtesy of the Second Ephoreia of Prehistoric and Classical Antiquities, Athens.

Figure 23
Statue of Athena from a warehouse in the Peiraeus destroyed in the first century B.C. Found in 1959. Bronze, height 2.35 m (92½ in.). Peiraeus Museum. Photo courtesy of the Second Ephoreia of Prehistoric and Classical Antiquities, Athens.

a buyer who liked the "antique" style. The other bronzes are of styles whose origins were probably in the fourth or third century B.C., but whose popularity lasted through the second century A.D.[16] The marble herms are also of a well-known type that was produced for hundreds of years. Most of this shipment may already have had a purchaser, unless there was a market outside of the region of Kindya for the strange veiled Artemis Kindyas, whose arms and hands are wrapped mummylike in her garment.

Although the contents of this warehouse come from an excavated context, they are as enigmatic as the bronzes that have been fished from the sea. We do not know where these marbles and bronzes were intended to be seen, whether in a sanctuary, or in a private garden. We do not even know whether they were going to be part of a single ship's cargo. And though they were found in the Peiraeus, we cannot be certain that they are Athenian products.

Sulla's sack of Athens and its port in 86 B.C. was his retaliation against the Athenians for having allied themselves with Mithridates of Pontus against Rome. But the destruction was only a temporary setback for this political and cultural capital. Greece was already a Roman province, and in the course of fighting their battles on Greek soil, many prominent Roman military leaders visited Athens, including Pompey, Julius Caesar, Brutus, Cassius, and Mark Antony. The writers Cicero, Horace, and Ovid also went to Athens, as did Augustus, the first emperor of Rome.

Athens flourished during the second century A.D. There were new buildings in the city center—libraries, concert halls, gymnasia, temples. The Roman emperor Hadrian was a special patron of the city, and the Athenians named him a tribal hero. The prominent Athenian Herodes Atticus spent much money to embellish the center of the city. Pausanias traveled in Greece during this period and wrote his ten-volume work, *Description of Greece*, in which he describes the regions, cities, and sanctuaries of Greece, covering topography, history, religion, and local customs and beliefs, as well as buildings and monuments.

Pausanias's meticulous description of Athens, and of all the places he visited, forms the basis of our knowledge of the appearance of Greek cities and sanctuaries, of what they contained, and of how monuments were presented to the public. That later travelers used his guidebook is evident from the fact that at least nine manuscripts of it have survived. Today, his writings help to build a fuller picture of the ancient world than what we see in the all-too-fragmentary buildings and monuments remaining for us to excavate.

The settlements of Athens have, since the Neolithic period, been constructed around the striking limestone outcrop known as the Akropolis, easily fortified and commanding a view far and wide. Pausanias, like travelers of all periods, makes his way there as he comes up to the city from the Peiraeus. He passes by some important graves, then goes through the major city gate in the region of the city known as the *Kerameikos* (the potters' quarter). The ceremonial street, the Panathenaic Way, leads through the *Agora* (the marketplace) and then up the western—and least precipitous—slope of the Akropolis [FIGURE 24].

Soon Pausanias leaves the Sacred Way and takes a much more comprehensive excursion through the Agora. Along the way, he provides a fairly detailed list

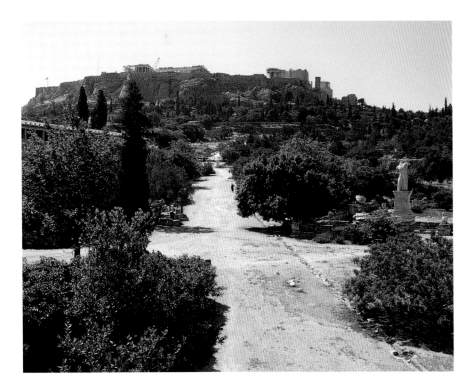

Figure 24
The Panathenaic Way
in Athens and a view
toward the Akropolis.
Photo: Mary Louise Hart.

of the buildings and monuments and gives information about related history and leg-
end. Inside the gate of the city, his first remarks are about *stoa*s (colonnaded buildings
used for shops), in front of which, he says, stand bronze statues of men and women
who are entitled to honors (1.2.4). From then on, until he comes down from the
Akropolis and leaves the center of the city, Pausanias makes specific note of some
150 statues, about half of them representing deities and mythical figures, the other half
being mortals. He says quite a bit about the statues of gods and goddesses, about
groups of figures, about personifications, even about statues of animals. As for the
statues commemorating individual people, unless he has a story to tell about the per-
son or about an event in which the person participated, he may simply identify some-
one as a poet, a leader, a warrior, a hero, or an athlete. We know many of their names,
and we can assume that, because they are of standard types, Pausanias does not describe
the statues—they are simply standing or striding figures.

He also names more than twenty artists. The names that we still recognize
today are those of men who worked during the sixth, fifth, and fourth centuries B.C.

To Pausanias, who lived in the mid-second century A.D., these were long-dead artists; their works were of great antiquity and were far more interesting to him than works made in his own day.

Pausanias does not often distinguish between bronze and marble statues, though he sometimes specifies bronze. He is careful to mention statues that are made of wood (in which case, he may go on to say that they are very crude or ancient in style), or terracotta (evidently fairly uncommon), silver (very rich dedications), and *chryselephantine* (gold and ivory, generally reserved for cult statues).

Often he gives the general locations of statues with respect to nearby buildings or other monuments, such as altars or sanctuaries. He expects us to know that statues are erected outdoors, except in particular circumstances. For example, a gold-and-ivory cult statue would have to stand inside the temple, and an expensive silver statue would also be kept indoors for safety.

There are certain categories of images that Pausanias tells us he is going to pass over, such as the less-important portraits, the many typical statues of gods, and the horsemen at the entrance to the Akropolis. By this last, we cannot tell from his text whether he means there are lots of them, or whether he is just referring to a well-known pair, one on each side of the entrance. What he really likes to tell us about are the very old and crude images. These include a few seated figures, instead of the usual standing images. He also likes to mention statues of animals—a bull about to be sacrificed, or a lioness. He particularly enjoys describing curiosities, such as a *bronze* statue of the *wooden* Trojan Horse with some Greek heroes peeking out of it, and a statue of Gē (Earth) begging Zeus to rain on her.

He is impressed by technical skill, mentioning one statue as being of interest not only for its antiquity (probably of fifth-century-B.C. date), but also for *technē* (technical and artistic skill). One such statue is a helmeted man with silver fingernails made by Kleoitos (1.24.3). Pausanias says nothing more, neither who is represented, nor in what manner. We need only imagine the usual type of standing figure, nude except for a helmet, distinguished only by the silver fingernails on the hands that hold the spear and carry the shield.

He also particularly likes one elaborate composition that represents the legendary Athenian hero Theseus rolling away a stone to retrieve the boots and sword that Aegeus, the king of Athens, left there for him. Pausanias reports that Theseus, boots, and sword are made of bronze, but the stone is a real one.

PORTRAITS

As he passes by the *Prytaneion* (town hall), Pausanias sees portrait statues of two great sixth- to fifth-century Athenians, Miltiades and Themistokles, and he makes the curious observation that the inscriptions have been altered so that now the statues honor a Roman and a Thracian (1.18.3). In other words, the portraits of an earlier time have been reused, which suggests that, in general, portrait statues must have followed a predictable type, so that one leader looked very much like another leader. We can assume that they were the traditional standing figures, nude, equipped with a helmet, spear or sword in the right hand, a shield on the left arm. Beards and mature physiques—idealized, of course—would have identified Miltiades and Themistokles as middle-aged individuals. Their bodies would likewise have been heroized to suggest power and authority.

Greek freestanding sculptures generally adhered to certain fixed types. Distinguishing features were youth or maturity, and attributes: a palm branch or a victor's fillet for an athlete, for instance, or a spear and a helmet for a military hero. The Riace Bronzes are good examples of this type of portrait statue as applied to mature men [see FIGURES 13, 14]. Another colossal bronze statue of a leader is shown as a younger man with a short incised beard [FIGURE 25]. This powerful man resting his weight on a lance clearly belongs to the tradition of Lysippos's famous statue of Alexander the Great, which so many other sculptors imitated, substituting their own portraits for Alexander's legendary features.[17]

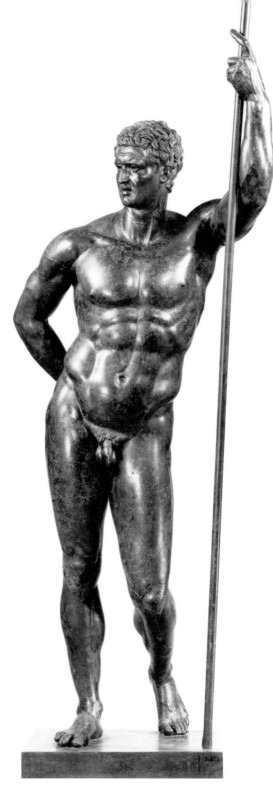

The image of a less individualized portrait than that of Alexander the Great might easily be reused as representing someone else, simply by changing the name in the inscription on its stone base. In the first century A.D., Dio Chrysostom angrily denounced the Rhodians for this practice, which he contended was widespread.

> Whenever you vote to honor anyone with a statue—and the idea of doing this comes to you quite easily because you have a vast supply of statues on hand . . . presto! there he stands before a vote has even been taken! Your *strategos* [general] simply points to the first statue he sees among those that have previously been dedicated, and then, once the inscription that was on the base has been removed and another name has been engraved, the job is finished![18]

Dio is furious at the Rhodians for being lazy, cheap, and disrespectful. But only a hundred years later, Pausanias mentions the reinscribed statues of the two famous early Athenians, Miltiades and Themistokles, as if there is nothing particularly unusual about this practice. The implication of his remark is fascinating, for it means that, for the most part, images of important people were not individualized. *Names* were more important than physical characteristics. Apparently, the sculptural styles for these generalized works did not change significantly over long periods of time. The same statues that served to honor heroes in fifth-century-B.C. Athens could work centuries later for a Roman honoree, not to mention for a Thracian who, being represented in Athens, was obviously happy to look like an Athenian. And why not reuse the statue of Themistokles, especially since his mother was a Thracian?[19]

THE TEN ATHENIAN TRIBAL HEROES • In the *Tholos* (round building) at the southwest corner of the Agora, fifty *prytaneis* (representatives of the ten tribes of Attica) took charge of the routine administrative, political, and religious activities of Athens. Near the Tholos, Pausanias saw statues of the *Eponymoi* (the heroes from whom the Athenian tribes got their names). The 16-m-long base for these public statues lies just north of the Tholos, in front of the *Metroön* (temple to the Mother of the Gods).

As he passes by, Pausanias reads off the names of the ten original heroes as well as those of three statues that were added later. He says quite a bit about the legends associated with some of them (1.5.1–5). When they are mythic, the Eponymoi are colorful figures. In vase-paintings it is hard to keep track of their guises, ages, attributes, and

activities. But here the group simply represents the political divisions of Attica, and so each tribe must have had equal representation. Public notices for the tribes were posted on the fence surrounding the statues, and people went there to read military and legal notices, not to judge the relative merits of the statues. The statues were generic, and they showed interested individuals where to find the notices relating to their tribes. From a political point of view, the statues are noteworthy, but as sculpture, they were not.

Only fragments of the top of the long base survive, but enough is left of the cuttings used to anchor the feet of the statues to show that the images were made of bronze, and that they stood at regular intervals. The type of statue was surely familiar, for here they were always defined as a group. They must have been bearded and cloaked, perhaps leaning on staffs. Ten cloaked figures on the East Frieze of the Parthenon are usually identified as the Eponymoi, as are the cloaked bystanders who appear so often in Greek vase-paintings, probably included as a familiar reference to a prosperous and smoothly functioning Athenian society. Such figures would need no explanation, and Pausanias sees nothing noteworthy in their appearance.[20]

THE TWO TYRANT SLAYERS · "I rather believe that the first portrait statues officially erected at Athens were those of the tyrannicides Harmodios and Aristogeiton" (Pliny 34.9). Pausanias has a good deal to say about these bronze statues in the middle of the Agora near the Temple of Ares (1.8.5). They were landmarks—the earliest public commemorative statuary ever erected in the center of Athens. The reason for the men's fame is an oft-repeated story in the literary testimonia. In 514 B.C., they had assassinated Hipparchos, son and successor of the Athenian tyrant Peisistratos, and had thus helped to bring democracy to Athens. In fact, Thucydides reports that Harmodios and Aristogeiton were lovers. The younger one, Harmodios, had twice turned down the amorous advances of Hipparchos, who retaliated by insulting the youth's sister.[21] It was Hippias, the elder brother of Hipparchos, who actually held the power. When the political conspiracy to kill Hippias went wrong, Harmodios and Aristogeiton took their own personal revenge and murdered Hipparchos. They were in turn both killed, and for a short time the Athenians suffered even greater oppression than before. The fact that the role of the Tyrant Slayers in bringing democracy to Athens had been a peripheral one was overlooked, and after the fall of the tyranny in 510 B.C., the Athenian citizens commissioned Antenor to make bronze statues honoring the mature Aristogeiton and his youthful lover Harmodios.

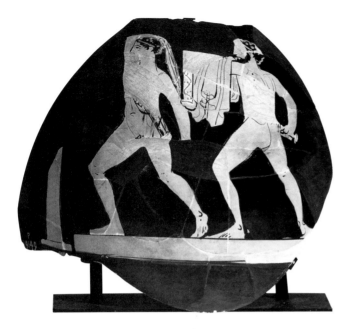

Despite his interest in the statues, Pausanias does not describe them! They are now lost, but many illustrations of them survive, in vase-paintings [FIGURE 26], on coins, and even in a relief on the so-called Elgin Throne in the Getty Museum (74.AA.12). The statues were also reproduced on a large scale in antiquity. During the Roman period, molds were taken in Athens and shipped in sections to Italy, where plaster casts were made from them for the production of marble replicas. One pair of Tyrant Slayers was evidently made for the emperor Hadrian's villa at Tivoli, near Rome.[22] Marble reproductions were also available for villa owners around the Bay of Naples, as we know from part of a plaster cast of the head of Aristogeiton that was found in a sculptor's workshop at Baiae.[23]

The original bronze statues revealed almost nothing about the personalities or actual appearances of Harmodios and Aristogeiton. On the contrary, both belonged to the familiar genre of the striding, attacking god or hero. The two nude statues stood back to back, one of them perhaps somewhat in advance of the other, swords in hand and poised for attack. Their idealized, well-muscled bodies and expressionless faces would make them virtually indistinguishable, were Aristogeiton not bearded and Harmodios clean shaven, following the standard Greek mode of representing maturity and youth.

Oddly enough, in Pausanias's day, there were not just two Tyrant Slayers, but four. In 480 B.C., the Persian army under Xerxes invaded and destroyed Athens. They took the original statue group back to Persia as a trophy. Just three years later, a new statue group of the Tyrant Slayers by the prominent artists Kritios and Nesiotes was erected in a central location in the Agora. There was a restriction against putting other statues too close to these great political heroes. Either Alexander the Great or one of his successors brought Antenor's statues back from Persia and returned them to Athens. From then on, the two pairs of statues stood side by side in the city center.

A BLUE-EYED ATHENA · The Temple of Hephaistos in Athens, though now unpainted, otherwise still looks today much as it did when Pausanias saw it, though there is no trace of the remarkable statue of Athena with blue eyes instead of her usual gray ones (Pausanias 1.14.6). We do, however, have considerable evidence about how ancient bronze statues were enhanced with color. The eyes of statues were frequently inserted, as was the case with the Getty bronze. A surviving eye from another statue is characteristic [FIGURE 27]: the white is made of glass frit,

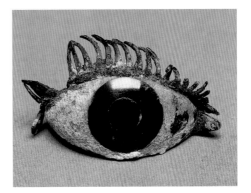

Figure 27
Right eye from a bronze statue. From a flea market in Geneva. Glass and glass frit, with cut copper lashes attached with a fixative of natural resin mixed with wax, length 4.9 cm (2 in.). Malibu, J. Paul Getty Museum (84.AI.625).

the glass iris is colored gray with manganese, and the glass pupil is blackened with manganese and iron. The lashes are cut from a folded sheet of copper, originally glued into the socket with resin and wax.

Besides lifelike inserted eyes, the teeth and fingernails of a statue may be made of silver, the lips and nipples of reddish copper, and ribbons and decorations on garments inlaid of the same materials. Jewelry could be added. The bronze statue itself might be patinated to give different colors to different parts of the surface. Pliny writes (34.98) that lead mixed with Cypriot copper produces bronze with the purple color that one sees in robes with purple borders. A mixture that resulted in a brown coloration was preferred for portrait statues.[24] Pliny describes a statue of Athamas colored red for shame because he has just thrown his son off a rock (34.140). Plutarch praises a statue of Iocasta, the mother of Oedipus, which had a pale face because she was about to die. This, he says, was created by adding silver.[25]

The bronze statues of today are also given artificial chemical patinas to define flesh colors and to bring out the materials and textures of clothing and attributes. Indeed, J. Seward Johnson, Jr., an immensely popular artist, uses automotive paint and inserted glass eyes to make his bronze statues appear more lifelike. This practice shows very much the same intention as that of the classical artist who used inserted eyes for the Getty bronze.

HERMES OF THE MARKETPLACE · A statue of Hermes, god of commerce, stood in the center of Athens. Lucian, a satirist who saw the statue in the second century A.D., at about the same time as Pausanias did, quipped that the "Hermes of the Agora, the one by the Painted Stoa, . . . is all covered over with pitch ·on account of being

molded every day by the sculptors."[26] As with the Tyrant Slayers, then, casts would be made from those molds for the production of replicas. We can imagine that this image of Hermes, like a statuette found in the Athenian Agora, was a youthful nude with wings on his heels, wearing his trademark pointed cap and a *chlamys* (short cloak) over his shoulders. A *caduceus* (staff) in one hand and a purse in the other defined his importance in the marketplace.

HADRIAN'S GIFTS TO ATHENS • Before he describes the buildings, monuments, and dedications on the Akropolis, Pausanias takes us to the Sanctuary of Olympian Zeus, south of the Akropolis. Not long before this visit, the emperor Hadrian had dedicated the temple and a colossal chryselephantine (gold and ivory) cult statue of Zeus, one of the largest that Pausanias saw. Besides four statues of Hadrian in front of the temple, two of Thasian marble and two of Egyptian stone, and the many note-worthy antiquities within the sanctuary, Pausanias remarks that the precincts were full of statues, *every city* having dedicated a portrait of Hadrian. If these had not all been very much alike, Pausanias would surely have remarked on which were the biggest, the richest, or the finest. He does not do so, nor does he say who made these new stat-ues, nor of what material they were fashioned. But he mentions other buildings that Hadrian made for the Athenians, the use of Phrygian marble, alabaster, and Libyan stone, as well as the statues, the paintings, and the books in those buildings.

THE BRONZE ATHENA ON THE AKROPOLIS • The Akropolis was crowded with monuments. Pausanias describes buildings, shrines, statues, dedications of all kinds, and, as usual, whatever else seems worth pointing out to the visitor. Of the commemora-tive statues, there are generals, admirals, heroes and casualties from battles and wars, political leaders (including Perikles and his father Xanthippos), the poet Anakreon, and many statues of deities. There were at least a few statues of victorious athletes: one of Epicharinos, who won the armored footrace; and another of the *pankratiast* (wrestler, boxer) Hermolykos. Pausanias does not describe these statues. He is far more interested in the other statues nearby: the bronze Trojan Horse, Athena striking the satyr Marsyas, Theseus fighting the Minotaur, Phrixos cooking the shanks of his sacrificial ram, and Herakles strangling the serpents. There are far too many curiosities on the Akropolis for Pausanias to pause for statues of athletes, who probably stood holding a fillet or a palm branch in one hand, the other hand raised toward a simple victory wreath.

As we have seen (p. 24), the Bronze Athena by Pheidias (about 456 B.C.) was one of many famous local statues and monuments that were commemorated on Athenian coins during the Roman period, some of them minted during the reign of the emperor Hadrian.[27] The Bronze Athena stood perhaps fifty feet tall. She wore her *aegis* (a breastplate bearing the head of the Gorgon Medusa) and a crested helmet, carried a shield on her left arm, and held her huge gleaming spear upright in her right hand. Because the statue was a public monument honoring the defeat of the Persians at Marathon in 479 B.C., its production costs were carved in stone for the public record. The statue cost more than eighty talents, with all wages and materials listed separately for each of the nine years that it took to make the statue, from 465 to 456 B.C.[28] The majesty and dignity of Pheidias's sculptures[29] had tremendous popular appeal, and his work was always in demand. More famous than his Athena Promachos was his colossal chryselephantine Athena Parthenos, the cult statue for the Parthenon. Pheidias also oversaw the design of the building program on the Akropolis initiated by Perikles in 448 B.C. Later Pheidias went to Olympia, where he made the huge chryselephantine cult statue of Zeus, one of the Seven Wonders of the World.

Pheidias specialized in images of gods, a field that by the fifth century B.C. already had a long tradition. Other great artists of the day concentrated on developing a relatively new area, that of athletic statuary, which began and flowered in Olympia. Statues of the same general type as the Victorious Youth, standing nude and confident, one hand raised to a wreath, the other arm probably cradling a palm branch, were erected by the hundreds at Olympia, Delphi, Nemea, and Isthmia, the sites of the Panhellenic Games, and in the home cities of the victors.

It is difficult today to imagine how the city of Athens looked when Pausanias visited there. For a modern parallel, we might turn to Washington, D.C., a much-visited city especially noted for its commemorative monuments. A catalogue of major public sculptures on government property and on the grounds of foreign embassies and national organizations lists about four hundred works, all erected in less than 150 years. Monuments in museums and on their grounds are excluded, as are "minor" monuments in cemeteries, on buildings, and in private homes and gardens.[30] Pausanias saw some public monuments in Athens that had been on view for nine hundred years, and his intentional exclusions were somewhat different, probably often simply meant to avoid repetition.

STATUES FOR VICTORS

The detailed account that Pausanias gives of what he saw and learned in Athens is, so far as we can tell, very accurate. In the ancient athletic sanctuaries, Pausanias likewise remains our most honest and thorough guide to the buildings and monuments. We should not be surprised that he does not mention a statue that we can recognize as the Victorious Youth, which was one of legions of statues honoring victors in numerous cities and sanctuaries. There were images of athletes in action, but these were surely far fewer in numbers than images of the athlete simply as honoree, standing, naked as in competition, one hand holding an attribute or raised to the victor's wreath. Most of these were small-scale [FIGURE 28]—bronze statuettes atop bases that would raise them to eye level—but there were also many full-size statues. In the first century A.D. Pliny estimated there were about three thousand statues at Olympia: how many of them, like the Getty bronze, honored athletes?

At the time of Pausanias, in the second century A.D., athletic contests were held in about three hundred places throughout Greece. The Panhellenic Games were held at Delphi, Olympia, Nemea, and Isthmia, all of which were also religious sanctuaries. At Delphi, the games were held in honor of Apollo, at Olympia and Nemea in honor of Zeus, and at Isthmia in honor of Poseidon. At Delphi and Olympia, contests were held every four years; at Nemea and Isthmia, every two years. According to tradition, the Olympic Games were founded in 776 B.C. The Greek calendar was calculated in four-year increments (the Olympiads) from that date onward. The contests at the other three major sites were said to have been founded early in the sixth century. The games, like the sanctuaries in which they were held, survived until the late fourth or early fifth century A.D., by which time Christianity had become the official religion.

The events in all of the games included footraces, combat sports, the pentathlon, horse racing, and chariot racing. It was customary at Olympia for some events to have separate contests for boys and adults. At other games there might be separate classes of events for *mellephebes* (prepubescent boys), for *ephebes* (young men), and for mature men. At Delphi, Isthmia, and Nemea, there were also contests in singing and in playing the lyre and the flute. At Olympia, trumpeters and heralds competed to

Figure 28
Statuette from Olympia, about 550–525 B.C. Bronze, height with base 17.8 cm (7 in.). Olympia (B 2400). Photo courtesy of DAI, Athens, neg. no. OL 2746.

36

announce the events and their winners, orators gave speeches, and poets sang poems. Victors at all four sites were awarded wreaths of leaves—laurel at Delphi, olive at Olympia, pine at Isthmia, and wild celery at Nemea. At games elsewhere, the wreaths were made of palm. It may be that all victors also received a palm frond, and the Getty bronze could easily have held one (Pausanias 8.48.2–3). Pausanias concentrates on the two largest and most important sanctuaries, Delphi and Olympia, telling us a great deal about each of them.

DELPHI

The oracle at Delphi was consulted by individuals from every corner of the Mediterranean world and the Near East, both Greeks and non-Greeks. The Pythian games there were held in memory of the Python, a serpent son of Gē, the goddess of the earth. The Python was defeated by Apollo, to whom the sanctuary was dedicated, and whom the victors represented. Victors in the games were given laurel wreaths, for laurel was sacred to Apollo. Indeed, Apollo usually figures as prominently in Pindar's victory odes as do the victors themselves.

> You, Apollo, wielder of the bow
> that strikes from afar,
> lord of the gleaming temple
> in Delphi's valley,
> where the world assembles—
> there you honored
> Aristomenes with the best of prizes;
> and at home in your festival
> you gave him victory
> in the pentathlon.[31]

In Pindar's dozen Pythian Odes to athletes composed between 498 and 446 B.C. we read the characteristically abundant praises for winners—of a horse race, wrestling, a footrace in armor, of two types of races for boys, of a flute contest, and of chariot races. If honorary statues of these individuals were also erected, they have vanished. The monuments Pausanias describes are, for the most part, not related to sports. His explanation is characteristically honest: "The sacred enclosure of Apollo . . . is

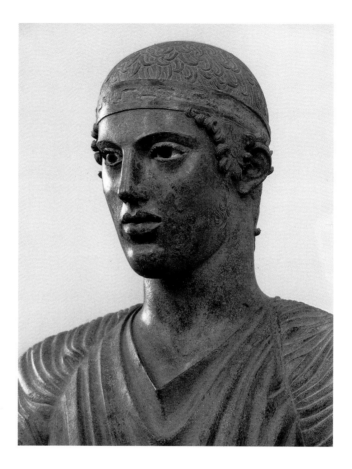

very large. . . . I will mention which of the votive offerings seemed to me most worthy of notice. The athletes and competitors in music that the majority of mankind have neglected, are, I think, scarcely worthy of serious attention; and the athletes who have left a reputation behind them I have set forth in my account of Elis" (10.9.1–2).

A few lavish monuments honoring athletes and their families still survive. One of the people for whom Pindar wrote victory odes was Hieron I, the tyrant of Syracuse from 478 until 467/466 B.C., who built a monument to commemorate the victory of his brother Polyzalos's chariot team. The life-size depiction of a young man dressed as a charioteer is today one of the most famous bronze statues surviving from classical antiquity [FIGURE 29]. Found with the statue known as the Delphi Charioteer were a bronze horse's hoof; two hind legs; a tail; the spoke of a wheel; a yoke; withers pads, reins, and other harness fragments; as well as the outstretched arm

of a youth. These are the remains of a life-size bronze four-horse chariot group with at least one groom holding the reins of the lead horse on the right side of the team. Part of an inscribed stone base survives, naming the owner of the victorious chariot as Polyzalos of Gela, whose chariots were victorious at Delphi in 478 and 474 B.C. In 373 B.C., his expensive dedication was apparently destroyed by an earthquake and landslides, and pieces of the chariot group were buried in earth fill behind a new retaining wall.

 The life-size bronze charioteer represents a young man standing still in his chariot, holding the reins of his victorious team. His acute concentration is riveting, because of the inserted eyes; his stillness is not stiffness, for his lips are slightly parted, revealing silver teeth. Around his head is a ribbon inlaid with a silver meander. The Delphi Charioteer is a powerful testimonial to the richness of the dedications at Delphi. Is this a portrait of the young driver? Probably not. Even though Pindar is not averse to naming a charioteer, he does not forget that his odes were addressed to the owners of such chariots. We can conclude that the Delphi Charioteer is simply an image of an idealized youth, for this was, after all, a victory monument commissioned by Polyzalos.

 Pausanias could not have seen this chariot group, since it had been buried in 373 B.C., but he notes at least three others. He also sees bronze horses and oxen, a goat, a dolphin, a wolf, a donkey, and a lion. He sees works made of iron—a group of Herakles fighting the Hydra, and a huge tripod stand. He is fascinated by the countless lavish votive offerings in the sanctuary at Delphi. There are statues of generals, of cavalry, and of important persons, dedicated by people from all over the Mediterranean world. Among the innumerable statues of Apollo are twenty bronzes given by the people of Lipara, one for each ship they captured in a sea battle against the Etruscans for control of the Tyrrhenian Sea. Among the mortals is a golden statue that Praxiteles made of his mistress Phryne, which she herself dedicated in the sanctuary (Pausanias 10.15.1).

 After the Greeks defeated the Persians at the Battle of Plataia in 479 B.C., the victors set up a bronze monument in the form of a column of entwined serpents supporting a golden tripod. Numerous attempts have been made to reconstruct the appearance of the Serpent Column and the tripod. The base for the column is still in situ in front of the Temple of Apollo, and the column itself, consisting of tightly coiled serpents rising to a height of 5.35 m, can today be seen in Istanbul, where it was

taken in the fourth century A.D.[32] During the 460s, Pheidias made a group of sixteen bronzes—statues of Athena, Apollo, and Miltiades, as well as the Athenian Eponymous Heroes—which were set up near the Serpent Column and near a bronze statue of the Wooden Horse at Troy. Miltiades and the Eponymous Heroes would all have been represented as mature bearded men. By the time Pausanias saw this group, statues of Antigonos, Demetrios, and Ptolemy had been added (10.10.1–2).

We might wonder why Pausanias chose to comment upon statues in Delphi that were closely similar to some of those that he had already found noteworthy in the city of Athens. The Wooden Horse and the Eponymous Heroes are only two examples of this habit. He tells us that the Athenians dedicated a bronze palm tree with a golden statue of Athena on top of it, spoils from their victories over the Persians at the Eurymedon River in southern Asia Minor in 467 B.C. (10.15.4). Another bronze palm tree had caught his eye in the Erechtheion on the Akropolis of Athens: it reached from an eternally burning golden lamp to the roof and served as a chimney for the smoke (1.26.6–7).

Battle groups were perhaps the grandest and most numerous dedications at Delphi, and these highly competitive political monuments had the desired effect upon Pausanias, who gives them lengthy descriptions, focusing upon accounts of the battles fought and won. One bronze group, commemorating the Spartan victory over the Athenian fleet at Aigospotami in 405 B.C., consisted of thirty-six statues made by nine different artists. Six of the statues represented gods, the rest were Spartans (10.9.6–10).

Among the many surviving dedications at Delphi that Pausanias does not mention is a large monument that stood a short distance up the hill from the Temple of Apollo. In 1894, the French uncovered a long limestone statue base and fragments of a row of nine marble statues representing eight men and Apollo. Inscriptions identify the men as belonging to six generations of one family. In 338–336 B.C., Daochos of Thessaly dedicated these "portrait statues" of his ancestors and living family members. All are powerful young men in prime physical condition, though some are dressed in businesslike attire while others are nude, corresponding to their individual achievements [FIGURE 30]. Agias, for example, the great-grandfather of Daochos, is represented as a naked and well-muscled young man because his most memorable feat was his great athletic career in the second decade of the fifth century B.C. He had won two victories at Delphi, five at Nemea, and five at Isthmia. And so, although Agias had

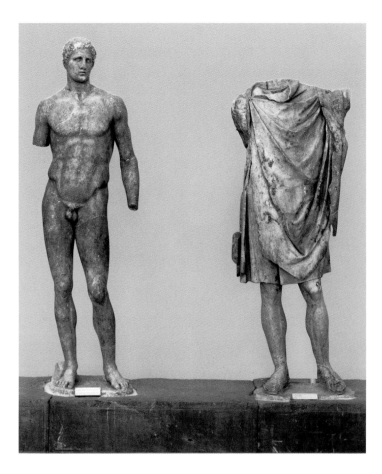

lived 150 years before Daochos, there is no hint that this is a statue of someone who was long dead. His image was meant to be read as a generalized description of a young and vigorous athlete.

Travelers to Delphi would have seen nothing unusual about the way in which Agias was represented in the monument dedicated by his great-grandson. The enduring message of monuments representing real people—both political and athletic—would have depended over the years upon their familiar, generic character and their inscriptions. The appearance was imaginary, illustrating the ideal long after the particular would have been forgotten. Although the strong young face of the Victorious Youth has prompted attempts at identification, and has even been compared with the Agias at Delphi, it is surely best read as the familiar face of victory, the idealized honoree.

Figure 30
Agias (left) and Aknonios, life-size statues from the Daochos dedication at Delphi, 338–336 B.C. Marble, height of Agias, 1.97 m (77½ in.); of Aknonios, 1.73 m (68⅛ in.). © EFA, V. Régnot.

Though Pausanias may note the same kinds of big and unusual monuments when he finds them in more than one place, it is fortunate for his readers that he does not find it necessary to list for us the numerous canonical statues of victors that he saw in every athletic center he visited. But this means that when we want to read about these statues, we must follow him to Olympia, the site at which he chooses to list victors and the honors bestowed upon them. Indeed, the archaeological evidence and the literary testimonia of other ancient authors also focus upon Olympia, which was, after all, the most important site for athletic contests in the classical world. As at Delphi, nobody proceeds so thoroughly and systematically through the sanctuary at Olympia as does Pausanias, and we rely upon him to bring the place to life.

OLYMPIA

The land of Elis contains two marvels. Here, and here only in Greece, does fine flax grow. . . . The fine flax of Elis is as fine as that of the Hebrews, but it is not so yellow. . . . Most of them [women of Patras] gain a livelihood from the fine flax that grows in Elis, weaving from it nets for the head as well as dresses.[33]

We can imagine Pausanias passing through vast fields of the lovely blue-flowered flax crop on his way to Olympia. Seventeen hundred years later, when Gustave Flaubert passed through Elis, he saw a very different landscape [FIGURE 31]. By that time, the fertile floodplain where the site of Olympia lies had been disturbed by the excavations conducted in 1829 by the French Scientific Expedition to the Morea, that is, the Peloponnesos. Instead of flax, Flaubert noted that

the mountains [were] covered with sometimes beautiful specimens of spruce and pine. . . . [They] fell away and the valley broadened out.

After an hour a hollow appeared in the side of the mountain along which we were travelling. This opened out into a large enclosed area bordered by sparse, wooded hills. . . . Two trenches marked the excavations of the French expedition: traces of enormous walls, some huge upturned stones, and a fluted column base of colossal girth were all that remained of ancient Olympia.[34]

Figure 31
View of Olympia. Photo:
Author.

In 1875, twenty-five years after Flaubert's visit, the Greeks gave the Germans formal permission to excavate at Olympia, a project that had been recommended enthusiastically in 1767 by the father of art history, Johann Joachim Winckelmann, even though he never visited Greece.

When Pausanias visited Olympia, Elis was a flourishing agricultural region, the sanctuary of Zeus was active, and the games were still held every four years. His lengthy description of the site, which fills nearly two books, begins with an account of the origins of the Olympic Games. The games were dedicated to Zeus, and, according to one story, were founded by the legendary hero Herakles. Our guide provides extensive historical, legendary, and sociological discussions, and lists several hundred noteworthy monuments, including nearly two hundred statues of victors. "My account will proceed to a description of the statues and votive offerings; but I think that it would be wrong to mix up the accounts of them. For whereas on the Athenian [Akropolis] statues are votive offerings like everything else, in the Altis some things only are dedicated in honor of the gods, and the statues are merely part of the prizes awarded to the victors" (5.21.1). A little later in his narrative, Pausanias defines the field for which he will be responsible, "those [sculptors] only will be mentioned who themselves gained some distinction, or whose statues happened to be better made than others" (6.1.2). In fact, some of the

Figure 32
Olympia. Statue bases
near the Echo Stoa.
Photo: Author.

Figure 33
Limestone statue base
with one bronze foot still
attached with lead tenon,
and cutting for the other
foot, third century B.C.
Olympia Museum. Photo:
Author.

inscribed bases for statues that he lists have been found, but we know of at least a hundred surviving inscribed bases for statues of victors that Pausanias simply ignored.[35]

As in Athens, Pausanias is concerned primarily with the older statues, works by famous artists, or works about which he has something in particular to say. His selection includes such oddities as a statue of a mare that threw her rider at the start of a race but still was honored because she ran on alone to win (6.13.9). As elsewhere, he is impressed by groups. One of the largest has Zeus, Thetis, and Hemera flanked on either side by five pairs of Trojan heroes, all on a single base; another bronze group shows thirty-five chorus boys who drowned, along with their trainer and their flutist (5.22.2 and 5.25.4). Soon after passing this group, he sees a row of praying boys, but here he does not count the statues (5.25.6).

Today there are rows and rows of statue bases, many still bearing inscriptions [FIGURE 32]. The socket holes for attaching the feet of the statues to the bases indicate that the missing statues usually were standing bronze figures. One particularly firm lead tenon still holds the foot of the statue that was torn off the base, perhaps for sale as scrap metal to a Roman art collector abroad [FIGURE 33]. This provides a good illustration of how the Victorious Youth could have broken at the ankles when it was removed from its original base to be shipped abroad.

Competing naked began in Greece in very early times, and as long as the Greek games survived, all but the equestrian athletes competed in the nude, even those running in the armored footrace. Pausanias dates the origin of this tradition to 720 B.C., when Orsippos of Megara won the footrace by letting his girdle or loincloth slip off because he realized that he could run more easily naked than clothed.[36] Plutarch tells us that the Romans disapproved of this custom.[37]

The tradition of setting up statues of victors in the athletic contests began during the third quarter of the sixth century B.C.

> The first athletes to have their statues dedicated at Olympia were Praxidamas of Aegina, victorious at boxing in the fifty-ninth festival [544 B.C.], and Rhexibios the Opuntian [from Locris Opuntia], a successful pancratiast at the sixty-first festival [536 B.C.]. These statues stand near the pillar of Oenomaüs, and are made of wood, Rhexibios of fig-wood and the Aeginetan of cypress, and his statue is less decayed than the other. (Pausanias 6.18.7)

Pliny tells us more about the appearance of the later statues of victors.

> It was not customary to make effigies of human beings unless they deserved lasting commemoration for some distinguished reason, in the first case victory in the sacred contests and particularly those at Olympia, where it was the custom to dedicate statues of all who had won a competition; these statues, in the case of those who had been victorious there three times, were modelled as exact personal likenesses of the winners. (34.16–17)

In 1880, a bronze head of a squinting leathery-faced man was found by the German excavators near the Prytaneion at Olympia [FIGURE 34]. Even though the head was found without its body, the squashed nose and cauliflower ears identify this individual as a boxer or a pancratiast. The aging bearded man has an air of dignity and satisfaction, and he surely represents an Olympic victor, for he wears an olive branch around his head, most of the leaves now missing. The casting is unusually thick, for the curly tufts of hair and the matted beard were worked almost entirely by hand in the wax, so as to create an individualized portrayal of this man. The portrait undoubtedly included the whole body, most likely a standing nude. But was the body

idealized and represented in peak physical condition, or was it scarred and sinewy to match the realistic rendering of the face? We have no way of knowing who the man was, but the face, probably that of an athlete who had won at least three contests, was perhaps familiar to some of the people who saw the statue.

The marble statue of Agias in the group at Delphi dedicated by Daochos is not as easy to recognize as a portrait of a specific individual [see FIGURE 30]. Sculptures of athletes usually show short-haired young men with a muscular frame and a gracefully cocked hip. If these features are characteristic of the fourth century B.C., is the same true for the deeply set eyes, the full mouth, the massive neck, and the muscular frame? Or was this statue intended in some sense to serve as a likeness of Agias? In this case, we are lucky enough to know that the person represented had won his

46

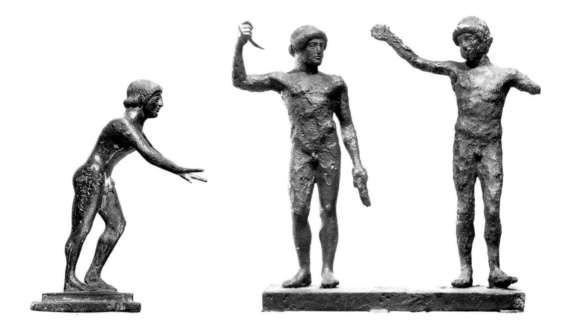

athletic victories 150 years before the dedication of the statue. Nobody in the fourth century would have been likely to have any idea of the actual appearance of this great-grandfather of Daochos.

At Delphi and Olympia, in addition to large-scale statues of victors, there were also more modest dedications in the form of statuettes. Often, these small-scale works have lively poses. For example, a small bronze runner is shown at the starting line [FIGURE 35], and a diskos thrower is in mid-swing; both statuettes are inscribed with the tribute "I belong to Zeus." A walking stallion in bronze that survives from an Olympia chariot group serves to remind us of the original context of the Delphi Charioteer [see FIGURE 29].[38]

In Delphi, it is often difficult to identify bronzes as victory monuments. A bronze flutist wearing a chiton must be a contestant, but some of the standing nude youths are just as likely to be Apollo as victorious athletes.[39] One group survives, consisting of two nude youths standing on a single base, turning toward one another [FIGURE 36]. The youth on the left bears his weight on his left leg; the youth on the right does the opposite. The one on the left holds a jumping weight in his lowered left hand and raises something in his right hand, perhaps a strigil; the one on the right gestures toward his companion, as if saluting him. Is he also an athlete?

Figure 35
Statuette of a runner, first half of fifth century B.C. Bronze, height 10.2 cm (4 in.). Olympia (B 26). Photo courtesy of DAI, Athens, neg. no. OL 811.

Figure 36
Two statuettes of athletes on a single base, mid-fifth century B.C. Bronze, height 16 cm (6¼ in.). Delphi Museum (7722). Photo courtesy of EFA, Athens.

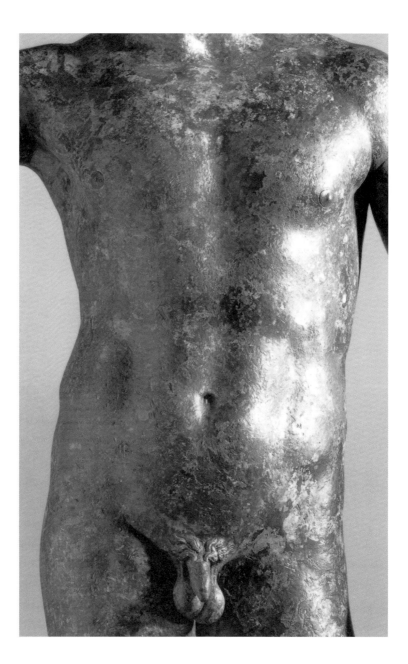

Figure 37
The Victorious Youth.
Torso.

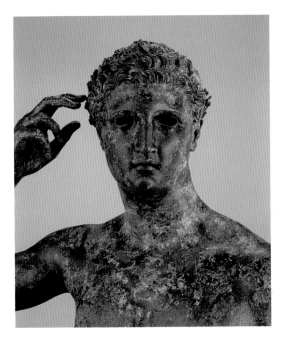
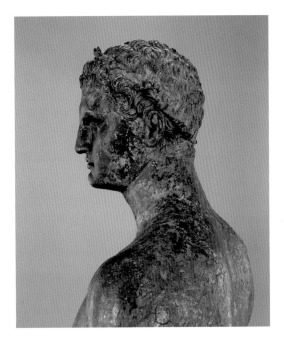

The fact that the Getty bronze is wreathed surely means that he is a victor in some athletic contest [see FRONTISPIECE]. Does his body suggest which event it might have been? He is a slender young man, his stance relaxed and confident. Neither torso nor back is noticeably muscular, his arms are long and rounded but not powerful, his buttocks are relatively small and understated. Many people have noticed the powerful calves, but this is not unusual in classical statues. A doctor might say that the smooth curves of his body represent a fat layer that is not seen in serious aerobic or strength training [FIGURE 37].[40] His fully matured genitals suggest that he is full grown, and the pubic hair is thick but concentrated in a relatively small area, which a doctor might call adult in character but not strictly correct in distribution.[41] This is, however, likely to be a generalized rendering. We must not forget that this is a sculpture, and that the artist was not necessarily driven by a need for absolute anatomical accuracy.

In what sense was the Getty bronze intended to be understood as a portrait of a particular person [FIGURES 38, 39]? The young man's neck is exceptionally thick and cylindrical. His face is baffling, for it seems to change as we move around the statue. From the front, we see smooth rounded cheeks, slightly parted fleshy lips,

Figure 38
The Victorious Youth. Head and chest.

Figure 39
The Victorious Youth. Left side of head and neck.

49

and thick short hair growing up from a low brow. But from the side, the information is different, for now we see a fleshy brow ridge, a long strong nose, and a heavy projecting chin. In profile, the cheeks lose their modulation, becoming flat and shallow, and the heavy neck is now too cylindrical. The shape of the eye and that of the mouth are nearly lost, and the bridge of the nose is too deeply indented. Would the inserted eyes have given subtlety to this gaze?

The young man's right hand is raised, the fingers with elegantly upturned tips loosely bent to touch the wreath that is tied around his hair, the ends twisted together at the back of his head. A number of leaves are still in place, but they are either broken or blunted and scratched from the early attempts at cleaning the bronze with what may have been a wire brush.

This is undoubtedly a victor's wreath, but is it olive or laurel? The leaves are slender oblongs, perhaps originally about two-to-three inches long. Most trees and bushes in both the olive and laurel families have leaves ranging from about two to five inches in length, though some are longer and some are broader than the norm. Generally speaking, however, olive leaves are likely to be smaller and more slender than laurel leaves. In other words, the sacred olive at Olympia and the sacred laurel at Delphi could be described similarly, but artists who were not also botanists were probably not particularly concerned about specificity. We cannot be absolutely certain that the small, slender leaves in the wreath of this statue are olive leaves, but it seems likely that they are [FIGURE 40].

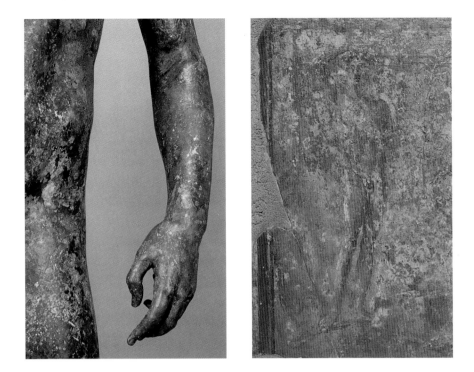

The statue's slightly bent left arm is lowered, and the elbow is cocked away from the body [FIGURE 41]. In the crook of the elbow was modeled a broad smooth depression, which would have steadied an object held in a loosely vertical position. The left hand is partially closed, as if bent around one end of the object. Was this a palm branch, and was the young man's gaze directed toward the slender leaves waving just beyond his shoulder [FIGURE 42]? Again we cannot be sure that this was the attribute he held, but it is a reasonable guess.

Leaving Elis, Pausanias observes for the second time that the region has good soil for growing fine flax (6.26.6), a point that may have occurred to him as he looked over a sea of the small pale-blue flowers. It may be coincidental that a few woven fibers found in the core of the statue may be linen, which is woven from flax (see p. 76). There is no question, however, that there were bronze-casting workshops in the region of the sanctuary of Zeus at Olympia, where there was one of the largest markets for bronzes in the classical world.[42]

Figure 41
The Victorious Youth. Left arm.

Figure 42
Athlete crowning himself. Detail of fresco, 41 × 40 cm (16⅛ × 15¾ in.). Found in Rome, under the Palazzo Pallavicini Rospigliosi. Rome, Museo Nazionale · Romano (103421). Photo courtesy of the Soprintendenza archeologica di Roma.

COLLECTORS IN ANTIQUITY

When bronze statues were removed from the cities and sanctuaries of Greece, they might be sold to Roman buyers through the thriving antiquities trade of the Graeco-Roman period. The appetite for antique styles was flourishing by the second century B.C. As late as the fourth and fifth centuries A.D., collections of statues continued to be assembled, and public buildings and private villas were still being decorated with statuary. Buyers often did not make their own selections but depended upon the services of dealers in Greece or in the Greek cities of South Italy and Sicily. These purveyors chose, bought, and shipped antiques to buyers in Italy and elsewhere in the Roman Empire. Statues like the Victorious Youth were bound for reinstallation, sometimes in public places, sometimes in private homes. Once they arrived at their destination, they would help shape the local taste for antiquities.

Beginning about A.D. 330, the empire's new capital at Constantinople became another destination for Greek bronze statues and trophies of all kinds. As the world became more thoroughly Christian, however, most ancient statues lost both their meaning and their significance. Bronzes were smashed by the thousands, to be sold in bulk as scrap metal for remelting and subsequent manufacture into weapons and other utilitarian objects.

In Book 34 of his *Natural History*, written in the third quarter of the first century A.D., Pliny provides a great deal of information about Greek bronze statues, who made them, and when. Like Pausanias, he is primarily interested in old statues. Most of the famous bronzes that he himself saw had been brought to Rome and reinstalled in public places. His writings echo contemporary tastes for the works of particular Greek artists. There were so many extant bronzes in Pliny's day, he explains, that he cannot begin to give a complete account of them. He suggests that Rome may have been even more crowded in the past. There were so many honorary portrait statues there by 179 B.C. that they had to be thinned out on the Capitoline Hill so as to clear a view of the Temple of Jupiter.[43] In 158 B.C., the Roman Forum likewise had to be cleared of extraneous statues. And Pliny has evidence that in 58 B.C. there were three thousand statues on the stage of a huge temporary theater in Rome.[44]

Vast collections of statuary were amassed as booty in Greece during the second and first centuries B.C. Many more were imported through more or less legitimate purchase for both private and public collections. Despite the plundering of Greece, in Pliny's day there were still thought to be about three thousand statues in the city of Rhodes, and similar numbers in Athens, in Olympia, and in Delphi. Pliny points out that he can barely enumerate the most famous Greek statues and Greek artists, considering that Lysippos of Sikyon alone probably made fifteen hundred statues, all of them so fine that each one could have made him famous (34.36–37). The large production of Lysippos in the fourth century B.C. no doubt had something to do with the fact that he came from a family of bronze workers. The ancient testimonia suggest that the family workshop developed a new method of increasing production, a lucrative enterprise. Statues of athletes were a specialty. When Lysippos won exclusive rights to make portrait statues of Alexander the Great, this would have added to the commissions for the family's workshop.

The statues that seem to impress Pliny most show that he had populist tastes. He thinks a statue of a dog licking a wound is a particularly successful work of art. For boldness of design he likes colossi—a statue of Apollo brought to Rome from Pontus in Asia Minor (45 ft. tall); a statue in Taranto by Lysippos (60 ft. tall); and the fallen ruins of the statue of the sun god, Helios, in the city of Rhodes (105 ft. tall) (34.39–42).

It is evident from Pliny that the Romans were well informed about classical antiquities. There are some obvious ancient restorations on marble statues, and we can be sure that bronzes, too, were restored in antiquity, just as ancient statues were when they were rediscovered in the Renaissance. Had the Getty bronze reached its final destination in Italy, instead of being lost at sea, it would surely have been a candidate for restoration of the legs and insertion of a new set of naturalistic eyes, made of stone, bone, or glass paste [see FIGURE 27]. A grave stele survives of a Roman restorer who actually specialized in replacing eyes.[45] Inventories and condition reports were kept of statues. Such records even had a precedent in Greece, in fourth-century-B.C. condition reports about statues and stelai that had been dedicated on the Athenian Akropolis.[46] Indeed, Roman guards at some sites told visitors stories about the statues that they were hired to protect.[47]

Cicero was an avid collector of antiquities during the 60s B.C. His collecting habits are known from a number of his letters to his friend Atticus in Athens, who bought sculptures for Cicero and made the arrangements to ship them to Italy.

We learn about the kinds of antique statues Atticus was choosing for Cicero's country villa at Tusculum, near Rome. Cicero is especially interested in acquiring sculptures for his gymnasium, which he calls his "Academy," probably in reference to Plato's Academy. Excerpts from Cicero's letters to Atticus help to illuminate the brisk trade in sculptures during the first half of the first century B.C.

Shipwrecks show us only some of the merchandise that was being carried on ships that went down on their way to Italy. Cicero expands upon this information by mentioning prices, naming his regular shipper in Athens, and referring to the ports in Latium to which his acquisitions were being shipped. In addition to the practical considerations, we get a clear sense of the nature of collecting and of the dependence of the buyer upon his dealer. When through the letters we become privy to this information, negotiations for purchases are already in progress. Most of the works are sure to have been antiques, though a few may not have been. Cicero is buying more than one shipment, and he is willing to pay good prices. He writes all but one of the following letters to Atticus from Rome.

> *Late November 68 B.C.:* Please carry out my commissions, and, as you
> suggest, buy anything else you think suitable for my Tusculan villa,
> if it is no trouble to you. It is the only place I find restful after a
> hard day's work. (1.5.5)

Tusculum is about fifteen miles southeast of Rome, in the Alban Hills. The villa was Cicero's retreat from the trials of life in Rome, and it was close enough to town to be readily accessible. Indeed, one of the letters in this series was written from Tusculum, rather than from Rome. His villa has not yet been identified by archaeologists.

It is interesting to note at the outset that Cicero has delegated to someone else the responsibility for choosing suitable antique sculptures to decorate his country house. We soon learn, however, that Atticus knew the villa well from having visited there himself, and that the two had the same taste in sculpture. Atticus evidently also knew what Cicero could afford to pay for antiques.

> *Later in November 68 B.C.:* If you can come across any articles of *vertu*
> fit for my Gymnasium, please don't let them slip. You know the
> place and what suits it. (1.6.2)

As the negotiations continue, Cicero's impatience for the purchase and arrival of his sculptures becomes abundantly clear. However, Atticus had other things to do besides buy sculptures for Cicero. Atticus published Cicero's writings, but he was also a writer himself, with works in the fields of chronology, history, genealogy, and biography.

> *First half of February 67 B.C.*: I have arranged to deposit £180 [20,400 sesterces] with L. Cincius on February the 13th. Please hurry up with the things you say you have bought and got ready for me. I want them as soon as possible. (1.7.1)

Today it is difficult to assess the spending value of 20,400 sesterces, and a recent estimate of $1,700 probably brings us little closer to the truth.[48] Was L. Cincius a banker or an agent? We might wonder whether he was responsible for delivering Cicero's payment to Atticus. At any rate, when Cicero writes again a short time later to tell Atticus that the payment has been made, we discover that it was intended to pay also for statues that were not from Athens but that were bought in Megara.

> *After February 13, 67 B.C.*: I have paid L. Cincius 20,400 sesterces for the Megarian statues in accordance with what you wrote me. As for those herms of yours in Pentelic marble with heads of bronze, about which you wrote me, they are already providing me in advance with considerable delight. And so I pray that you send them to me as soon as possible and also as many other statues and objects as seem to you appropriate to that place, and to my interests, and to your good taste—above all anything which seems to you suitable for a gymnasium or a running track. For I am in such an emotional transport owing to eagerness for this subject that I am deserving of help from you, if also perhaps of censure from others. If there is no ship belonging to Lentulus, have them loaded at any port you wish. (1.8.2)[49]

Here we learn that besides paying for the Megarian statues, Cicero has ordered some herms that Atticus had available. Herms are pillars crowned by a head, or sometimes two heads back to back [FIGURE 43]. They were first produced in Greece during the Archaic period, when the shafts were always crowned with the head of Hermes, protector of travelers, of cities, and of homes. These stylized images were

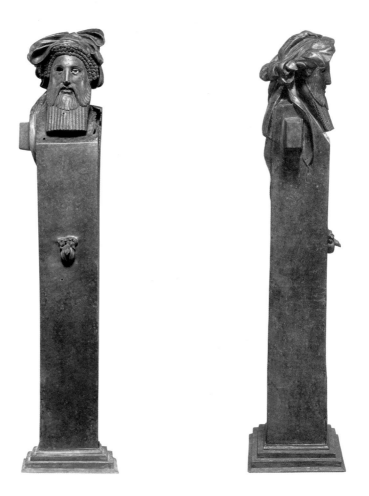

placed at street corners, boundaries, gateways, and beside doorways. Herms were also placed in the gymnasium and the palaestra.

By Cicero's time, herms might be made of marble or bronze, or they might be bronze busts set on marble shafts. The heads could represent gods and goddesses, or athletes, or they could be portraits of famous historical figures or of the homeowner and his family members. Herms were often inscribed.

Herms were popular ornaments for house and garden, and they might be placed in niches, colonnades, or galleries; they were even used for supports in balustrades. Some were designed with flat backs and with only the head and the top of the shaft so that they could be hung on a wall. A few are carved on gemstones.

The herms that Atticus had to offer Cicero had bronze heads placed on shafts made of Athenian Pentelic marble (1.8.2). The usual shipper is Lentulus, whose ships probably docked at the Peiraeus, but Cicero is so eager to have the herms that he is willing to forgo the services of Lentulus and even have the sculptures sent from some other port, which would certainly have added the cost of overland transport. Cicero seems to think that he may be subject to criticism for his growing impatience. Today we might also tire of his acquisitiveness.

> *Also in 67 B.C.*: Your letters are much too few and far between, considering that it is much easier for you to find someone coming to Rome than for me to find anyone going to Athens. Besides, you can be surer that I am at Rome than I can be that you are in Athens. (1.9.1)

> I am awaiting eagerly the Megarian statues and the Herms about which you wrote me. Anything which you have in any category which seems to you worthy of the "Academy," do not hesitate to send, and have confidence in my treasure chest. This sort of thing is my voluptuous pleasure. I am enquiring into those things which are most *gymnasiōdē*. Lentulus promises his ships. I beg you to see to this project diligently. (1.9.2)

So Atticus was not always in Athens but traveled in Greece as well. These delays made Cicero even more eager to buy additional sculptures. When he did not hear from Atticus for some time, he contacted Lentulus himself and made arrangements for the shipment of his newly acquired sculptures from Athens to Tusculum. Evidently, the works had been stored in Athens preparatory to shipment.

Was Atticus making buying trips specifically for Cicero, or was he making purchases for other clients as well? Certainly, buying the Megarian statues may have required a visit to Megara, which is thirty-nine miles from Athens. If the sculptures to be shipped to Cicero were already in Athens, as they seem to have been, it would be reasonable to conclude that Atticus had a supply of antique works of art, probably of popular types that were frequently in demand. We might be reminded of the well-stocked warehouse in the Peiraeus that was destroyed in the early first century B.C. (see pp. 24–25).

Before July 67 B.C.: As for my statues and the *Hermerakles*, I implore you in accordance with what you have written, to ship them at the first opportune moment which appears, and also anything else which seems to you suitable for this place, with which you are not unacquainted, and especially for a wrestling court and gymnasium. As a matter of fact, I have been writing to you while seated in that very location, so that the place itself informs me of what it needs. In addition I commission you to procure some reliefs which I could insert into the wall of my *atriolum* [a small atrium] and also two well-heads ornamented with figures. (1.10.3)[50]

The Hermerakles Cicero refers to is a herm ornamented with back-to-back heads of Herakles and Hermes. Despite again imploring Atticus to speed up the delivery of the art works, Cicero has not at all given up on his friend's reliability, for he asks him for more. Since Cicero seems to know exactly what he is asking for in the reliefs and the wellheads, we get the impression that these belonged to a contemporary line of works, newly produced, not antiques like the other pieces Atticus has had to seek out for his friend.

July or August 67 B.C.: Please send what you have purchased for my Academy as soon as possible. (1.11.3)

Once again, Cicero betrays his eagerness by repeating himself. In fact, his impatience surfaces in some way in every one of these letters. But soon the sculptures arrive, and the intensity wears off.

Late 67 B.C.: The statues you have obtained for me have been landed at Caieta. I have not seen them yet, as I have not had a chance of getting away from town; but I have sent a man to pay for the carriage. Many thanks for the trouble you've taken in getting them— so cheaply too. (1.3.1)

The port of Caieta (modern Gaeta) is about eighty miles south of Rome on the Via Appia, relatively close to Cicero's villa at Tusculum. Cicero's next shipment was delivered to Formiae (modern Formia), a Roman resort just east of Caieta.

Early 66 B.C.: What you wrote me about the *Hermathena* [herm with back-to-back heads of Hermes and Athena] is certainly pleasing. This is the sort of decoration which is appropriate for my Academy. . . . Naturally I would like you, in accordance with what you have written, to decorate this place with as many works of art as possible. As for those statues which you sent me previously, I have not yet seen them. They are in Formiae, to which I am just now intending to set out. I shall transport them all to the villa in Tusculum. (1.4.3)[51]

July 65 B.C.: Your *Hermathena* delights me greatly, and it is placed so beautifully that the whole gymnasium looks like a votive offering. (1.1.5)[52]

Cicero is much more critical four years later when he finds himself dissatisfied with some sculptures that he bought, again sight unseen, from another friend, M. Fadius Gallus. Cicero complains that they are not what he wanted, and that furthermore they are outrageously expensive. He says that he will, of course, defer to Gallus's good taste, but then he immediately criticizes his friend's art-historical expertise and asks whether the statues are at all appropriate for a gymnasium, as if Gallus should have known better. A group of bacchants is particularly abhorrent to Cicero. Apparently, these were contemporary works, mass-produced and widely available. In the end, after he finishes his diatribe, Cicero asks where and when he has to go to pick up his purchases, and what kind of conveyance will be needed to carry them, and in closing the letter, he reassures Gallus of their close friendship.[53] The negotiations are very similar to those conducted by today's dealers and buyers.

Clearly, the Roman trade in statuary was thriving in the first century B.C. Cicero, whose own role as a collector is so well documented, supplies us with a detailed record of why opprobrium was attached to certain kinds of collecting. He thus disapproved thoroughly of individuals who did not pay for what they collected, such as the many Romans who brought back statues as booty from Greece. Among the collectors of statuary was Mummius, who defeated Greece in 146 B.C., sacked Corinth of its treasures, and subsequently filled Rome with statues (Pliny 34.36). And when Sulla captured Athens in 86 B.C., he, too, carried off quantities of statues.

Cicero's censure of Verres brings to mind the ethical debates of today. Verres was the Roman governor of Sicily from 73 to 70 B.C. He appropriated so many antiquities that the Sicilians appealed to the Roman Senate to bring him to trial for misconduct and extortion. Cicero served as the prosecutor. His *Verrine Orations* describe in detail the art objects that Verres stole, not only in Sicily, but also in Delos, Chios, Erythrai, Halikarnassos, Tenedos, Samos, and Malta. In Sicily, Cicero accuses Verres of going to inspect every object made of silver; every gem; every object of gold and ivory; bronze, marble, and ivory statues; paintings; and tapestries, and then choosing for himself what he liked. Verres stole from public temples and from private collections. He forced the Sicilian collector Heius to sell him a number of statues by Myron, Polykleitos, and Praxiteles for the unbelievably low price of 6,500 sesterces.[54] He stole indiscriminately wherever he found objects he liked. Verres owned a marble Cupid by Praxiteles, a bronze Herakles by Myron, two bronze statues of girls by Polykleitos, and a statue of Sappho by Silanion.

Clearly, Cicero felt that Verres committed criminal acts, but that he himself was a legitimate collector. There was no conflict of interest when he prosecuted Verres for collecting by theft and extortion. In the next century, more than one emperor eagerly "collected" art from Greece, and there are horrifying accounts of their actions. For example, Tiberius became so infatuated with a statue in Rome of an *apoxyomenos* (youth using a strigil) by Lysippos that he had it removed from public view and put in his bedroom (Pliny 34.62). Nero so liked the statue of the youthful Alexander by Lysippos that he had it gilded (Pliny 34.63). Nero also "robbed Apollo [at Delphi] of five hundred bronze statues, some of gods, some of men" (Pausanias 10.7.1). When he traveled, Nero took along with him Strongylion's Amazon with the beautiful legs (Pliny 34.48 and 34.82). Statues taken by Nero to decorate his Golden House in Rome were later dedicated by Vespasian in the Temple of Peace and in other public buildings in Rome (Pliny 34.84). In other words, Vespasian turned over to the Roman people some of the statues that Nero had stolen from Greece.

We can only guess at the intended second home for the Victorious Youth, both a crowned victor and a handsome young man with thick hair, softly modeled flesh, and a gracefully cocked hip [FIGURE 44]. Had the eyes already fallen out when the statue was purchased for export? It seems likely that the statue came from a public setting, but there is no way to know whether it was going to another such home, whether its disappointed purchaser had been expecting to display the statue in his own home, or whether it was intended as scrap.

Figure 44
The Victorious Youth.
Back.

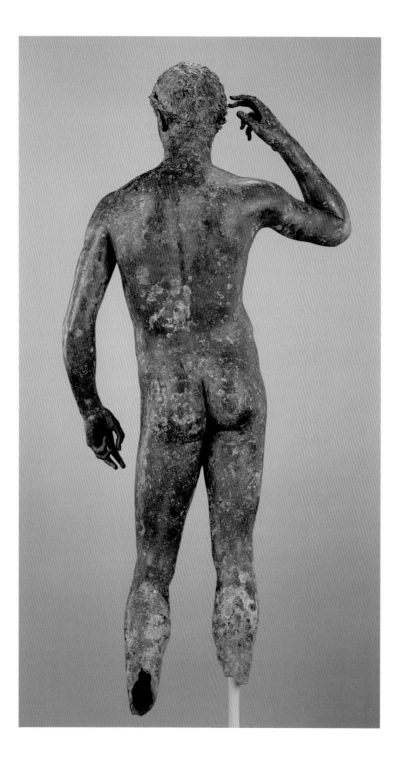

Collaborators: Artist and Craftsman

In considering the technical aspects of bronze statuary from the ancient world, conservators and conservation scientists have revealed dramatic links between art and craft that had not previously been suspected. Thus these specialists play a critical role in our investigations and help us to establish new parameters for the study of classical statuary.

Laboratory technologies have added a fascinating new dimension to the study of ancient sculpture. An endoscope equipped with a fiber-optic camera was used to examine the interior surface of the Getty bronze. Both X-radiography and the endoscope have provided us with information about how much was added to the wax working model before the statue was cast, about how the separately cast sections of the bronze were joined, and about how "original" or unique this statue really is. Samples of the metal were analyzed to determine the alloy, which turns out to be fairly unusual in its simplicity. Inclusions in the core material were examined microscopically, giving a more accurate evaluation of the statue's probable place of origin. And new carbon-14 tests on organic material from the core yielded dates with about the same range as the stylistic dates that art historians have suggested for the bronze![55]

Technē

In ancient Greece, art, craft, skill, cunning, and even trade were all defined by a single term: *technē*. It is important to bear this in mind in our assessment of any ancient statue. Indeed, at this point in the development of the study of ancient bronzes, technical observations may be more significant in our investigation of the origin and the uniqueness of a bronze than stylistic questions. But even technical revelations do not necessarily provide the answers that art historians have sought. Nor are the same questions always asked about ancient sculpture. We may now ask what the questions are that we should be posing in our study of a classical statue.

As he traveled through Greece, Pausanias took note of both individual statues and groups of statues. He does not usually describe the components of statue groups as being individualized works, which must mean that the statues in a group were as a rule more or less alike. For example, he says that there were two statue groups of the Athenian Eponymous Heroes—one in Athens and one in Delphi—but he does not have anything to say about any of the individual statues in either group: their representation as a group was the key to public recognition of who they were and how they functioned. At Olympia, in the statue group memorializing thirty-five chorus boys who had drowned, Kallon, the artist, had to make certain that the statues functioned as a group, so he could not have individualized them (Pausanias 5.25.2–4). Of course, groups might have some variation. At Delphi, one group of thirty-six statues was made by nine different artists (Pausanias 10.9.6–10). How different were they? We need to understand how this process worked if we are to understand the classical bronze industry and its products.

Pausanias gives us a clue to the sophistication of early Greek *technē*: he has seen two statues by the Archaic (sixth-century) artist Kanachos in two different places. The statues are identical except for the fact that one is made of bronze, and the other is made of wood (9.10.2). As early as the sixth century, then, the medium was the choice of the buyer, not of the artist. The artist provided the model, which could then be reproduced in one or more shops—in different places and in different media.

Lysippos came from a family that exemplified the concept of *technē*: some were sculptors, others were founders, and their roles were complementary. Their fourth-century-B.C. workshop was highly successful, marked by technical innovation and a vast output. Specific works by Lysippos are cited widely and approvingly by the ancient sources.[56] Lysippos was the visible representative, the *name* attached to the thriving family business, which seems to have charted new directions for bronze casters by streamlining production to satisfy the growing market for bronze statues. An especially large commission consisted of twenty-five equestrian statues representing the companions of Alexander who died fighting the Persians at the Granikos River in 334 B.C. The production was probably not unlike that used for the athletic statues

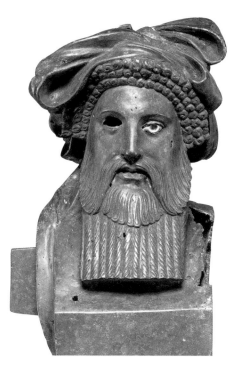
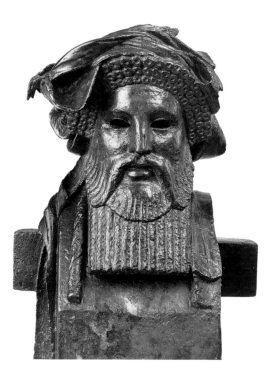

Figure 45
Head of herm of
Dionysos. Bronze, height
1.03 m (40½ in.). Mal-
ibu, J. Paul Getty Museum
(79.AB.138). See also
fig 43.

Figure 46
Head of herm of Dionysos
signed by Boëthos, prob-
ably mid-second cen-
tury B.C. From the Mahdia
shipwreck (90–60 B.C.).
Found in 1907. Bronze,
height 1.03 m (40½ in.).
Tunis, Bardo Museum
(F 107). Photo courtesy
of Rheinisches Landes-
museum, Bonn. Photo:
H. Lilienthal.

produced by the workshop under the name of Lysippos. A brother of Lysippos, Lysistratos, who is identified as a founder, is credited with having developed a method of reproducing likenesses and of molding copies from statues, in which, evidently, the wax working model was essentially complete and ready to cast just as it came out of the master molds. This must have speeded up the process, making the family business even more lucrative. The story that when Lysippos died he had a stash of fifteen hundred gold denarii, one for each statue that he had completed, may well be true (Pliny 34.37).

THE MARKET

By the end of the fourth century B.C., private buyers accounted for a vast new market for freestanding statuary. Throughout the Hellenistic and Roman periods, private buyers appreciated, collected, and commissioned works of many styles. New sculptural types and motifs were introduced, but old styles continued to be popular. One favorite image was the herm, a pillar which could be topped with the head of a god or a mortal [FIGURE 45; see also FIGURE 43].

Sometime during the second century B.C., someone evidently designed a new type of Dionysos, perhaps a head only, that represented the god of wine as a mature bearded individual wearing an elaborately wrapped turban. There are a number of examples of this kind of Dionysos, but three of them are essentially identical, and two of those are bronze. Each of the bronze heads is on a herm, that is, a squared pillar with rectangular bosses substituting for arms at the top, and a set of genitals about halfway down. Monuments like these probably served as house and garden ornaments. One of them comes from the shipwreck of the 80s B.C. near Mahdia off the coast of Tunisia [FIGURE 46]; the other, in the Getty Museum, has no known ancient context.[57] Differences in the condition of the two herms give the impression that the Getty herm's better-preserved features are crisper. However, the surface of the Mahdia herm is roughened from corrosion and from overcleaning at an early stage of its modern history.

The two bronze herms were apparently cast in the same workshop from the same original model, for the bronze alloys used to cast them are very similar, and the measurements of the two heads are basically identical, neither one measuring

Figure 47
Relief of Dionysos with wreath around his head, first century A.D. Excavated beside a pool within the peristyle of a house at Pompeii. Marble, height 27.5 cm (10 7/8 in.). Pompeii (2914). Photo courtesy of "L'Erma" di Bretschneider.

consistently either more or less than the other.[58] In this production line, piece molds would have been taken from the model and used to produce wax working models for each of the herms. These were separately worked over and finished before casting, and certain differences were introduced. For instance, the elaborate turbans are wrapped identically, but wax was added to the Mahdia herm to enhance the turban's detail.[59] A wreath of grape leaves was added, and two long spiraling curls were attached to the front of the herm. In contrast to this creative treatment of detail of the Mahdia Dionysos, the turban and hair of the Getty Dionysos were simply scraped and incised, as if speed was more important than individualized treatment.

It is surely significant that an inscription was cut in one wax arm boss of the Mahdia herm before casting: it names the maker as Boëthos of Chalkedon, a second-century-B.C. artist known to us from other ancient literary testimonia. Maybe the Getty herm was likewise inscribed by its maker, but its only surviving arm boss bears no inscription.

We might call these bronze herms two "editions" in a series of castings produced in one workshop from a single model. Was the man who signed the herm the technician who cast the bronze, or the craftsman who finished the working model, or the artist who made the original model? Or were those roles indistinguishable? There is no way to know whether the Getty herm was made at the same time as the Mahdia herm, but we know that this popular type of image survived for two hundred years or more, and that it could be purchased in at least one other medium, with variations. In A.D. 79, a virtually identical head of Dionysos was hanging beside the pool in the peristyle of a Pompeiian house [FIGURE 47]. This was not a whole herm but just a marble head with a flat back and a hole for suspension. A profusion of vine leaves is substituted for a turban. These three herms make it abundantly clear that what we understand as classical "style" was truly a matter of *technē*, and that art was inextricably linked to production techniques and to market demand.

THE LOST-WAX PROCESS

For many years, the traditional view of ancient sculpture was that Greek artists made original or unique bronze statues and that Roman copyists reproduced those originals in marble. And yet even the very first casting of a bronze is a copy of a model. The wax that is to be "lost" is the key to the appearance of the finished product, for the wax

that is to be melted out can be altered or embellished before each casting. The wax is a working model that can be shaped to produce variations, what we might call different "editions," of the original model. Many bronzes may be produced from that model, or very few, or the edition may be limited to a single bronze.

The lost-wax process was widely used from the earliest date at which bronzes were cast in the Mediterranean world. There were, of course, many variations in the details, introduced by different workshops and technicians, but the basic process was the same [FIGURE 48a–g]. In antiquity, as today, casting a bronze by the lost-wax process began with the construction of a model, which might best be described as the "artist's model" or the *original model* [FIGURE 48a]. The model could be made of any material and need not have been to full scale, a job that may well have been left in the hands of a skilled artisan. Once a model of the correct size had been made, clay *master molds* were taken from it in separate, joining sections [FIGURE 48b]. These molds were dried and then reassembled in groups of manageable sizes.

Each assemblage of master molds was lined with a layer of beeswax, which could be poured in, brushed on, or applied in thin sheets [FIGURE 48c]. Then the master molds were removed, and the beeswax sections of the statue were reassembled into a hollow wax "copy" of the model, which may be called the wax *working model* [FIGURE 48d]. Using master molds, one could recopy the original model (a) as often as necessary, usually to fill a commission for additional statues of the same type, but also to remake a casting that had been too flawed to repair. Furthermore, by manipulating the wax, one could produce a series of statues of similar dimensions and composition, but each with a different character, like the two herms [see FIGURES 45, 46].

When the wax working model was ready for casting, it would look almost exactly like the intended finished bronze. The wax model might be cast just as it came out of the master molds, with only a little touch-up of the seams and details, or it might be worked over extensively — to individualize the features, or to differentiate it from previous statues in the series. For example, the positions of arms and legs could be adjusted, and facial features could be altered. Wax could be added and modeled into a distinctive nose, or ears, or it could be used to make curling locks of long hair or of a beard. Details such as eyebrows and strands of hair could also be carved and modeled in the existing surface of the wax. Depressions or grooves might be cut in the wax surface where copper nipples, and lips, or even silver fingernails were to be inserted after casting.

a

b

c

iron
chaplet

d

funnel

vent

gate

e

f

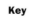

g

Key clay wax bronze

The wax working model for a large bronze would be cut into sections for casting. Then a liquid clay *core* was poured inside each hollow section in layers. An *armature*, consisting either of iron rods, or of sticks or other perishable materials, might be inserted to stabilize and strengthen the core.[60] Wax rods descending from a wax funnel—a *gate system*—were attached to each of the wax sections. Metal pins called *chaplets* were stuck through the wax model into the core, their heads left exposed [FIGURE 48e]. Then a clay *investment mold* was applied in layers over the entire wax working model and its attached gate system, leaving the top of the wax funnel exposed. The innermost layers of this mold were made of very fine slip so as to reproduce all of the surface details of the wax. As the investment mold was applied, it covered and fixed in place the heads of the chaplets, anchored within the core as well. When the clay had dried, the molds were upended and baked, the chaplets holding the core steady within the mold while the wax melted out through the hole that had once been the funnel [FIGURE 48f].

Finally, the investment molds were packed in sand, and then the bronze was melted. The temperature of molten bronze is about 1,000°C, but fluctuates according to the proportions of tin and/or lead in the alloy. The success of the pour depended upon speed, and upon how much two men could lift and maneuver quickly into position before the metal began to solidify. They had to pour the bronze through the now-empty funnel and channels of the gate system into the cavity left behind when the wax working model was melted. When the task was completed, the molds were cooled and then broken away from the casting, revealing a blackened bronze surface to which gates and chaplets remained attached [FIGURE 48g].

After the surface of the bronze had been cleaned of its *casting skin*, and the gates and chaplets had been cut away, the parts of the statue were joined and fixed in place by flow welding, a process in which molten bronze is poured along the juncture between two separate bronze sections. Surface flaws were cut out and repaired—usually with small rectangular patches—and the bronze was polished.

The final surface of a nude youth such as the Getty bronze is likely to have been pale and gleaming like flesh. The naturalism of this statue was originally intensified by lifelike inserted eyes [see FIGURE 27], and by inlaid nipples of reddish copper, which are still in position [see FIGURE 37]. Copper eyebrows and lips were also added on some statues, as were silver teeth and fingernails. These enhancements were sometimes carried to extremes. For instance, copper and silver might be used to

Figure 48a–g

The lost-wax casting process. *a*: the artist's model; *b*: clay master molds taken from the artist's model; *c*: excess hot wax is poured out of the master molds; *d*: finished wax working model with details marked, clay core poured inside, and metal chaplets stuck through wax into core; *e*: cross-section of wax working model with wax funnel, gates, and vents attached; *f*: cross-section of investment mold, with hollow tubes where wax working model and gate system have been burned out; *g*: cast bronze hand with core and clipped gate system. Drawings after Séan A. Hemingway.

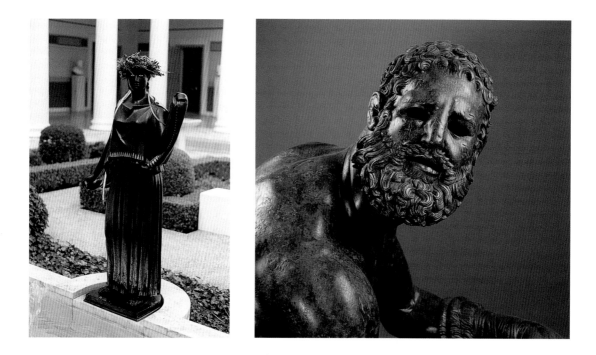

Figure 49
Modern reproduction of one of the group of "dancers" found in the Villa of the Papyri, Herculaneum (temporarily wreathed), as displayed in the Inner Peristyle of the Getty Museum in Malibu. Bronze with inset eyes and inlaid decorative borders on garment. Cast by the Fonderia Chiurazzi, Naples. Photo: Author.

Figure 50
Face and shoulder of seated boxer. Found in Rome in 1885. Bronze with inlaid copper lips and dripping blood, height 1.28 m (50 3/8 in.). Rome, Museo Nazionale Romano (1055). Photo courtesy of the Archäologisches Institut und Akademisches Kunstmuseum der Universität Bonn.

show the "pattern" on a garment [FIGURE 49]. One statue of an aging bronze boxer even has red copper "blood" dripping from cuts in his head and body [FIGURE 50]. In addition, the surfaces of many bronze statues were artificially patinated or painted.

INSIDE THE GETTY BRONZE

The bronze was X-radiographed by Jerry Podany, Antiquities Conservator at the Getty Museum [FIGURE 51]. Marie Svoboda, a post-graduate intern in Antiquities Conservation at the Museum, computer-scanned the X-radiographs of the statue and enhanced the details, diagramming numerous large squares on the back and front of the statue. Irregular thickness in the walls of a bronze shows where wax was applied unevenly within the master molds. Thus, if particular features are thicker than the rest of the casting, these are points where additions are likely to have been made to modify the wax model before casting. For instance, if the inner surface of the bronze is not indented at the nose, and the nose is solid bronze, this is a sign that the feature was added separately in wax to the working model. There are sure signs that this was the case with the head of the Getty bronze. In fact, the nose, the ears, and the

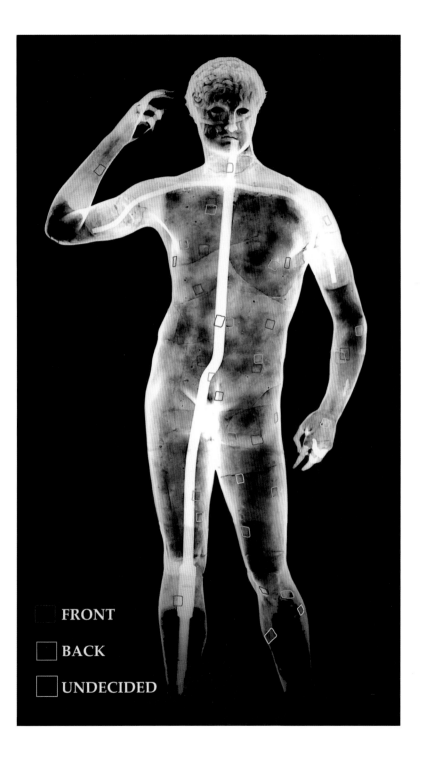

FRONT

BACK

UNDECIDED

Figure 51
The Victorious Youth.
X-radiograph with squares
enhanced. Computer
enhancement by Marie
Svoboda.

hair, opaque in the X-radiograph, are all thicker than the rest of the head: all were made of wax added to the working model, and all were modeled by hand to individualize the head and face before casting. These features are the evidence that prove unequivocally that the separately cast head of this statue was a unique production, an "original" in modern parlance. Thus even if this statue's limbs were simply assembled from parts available in the workshop, the head was separately modeled, and the finished bronze was indeed a unique casting [FIGURE 52]. On the top of the head, a roughly round gate (diameter about 2.5 cm) among the curls was simply broken off and otherwise left unfinished, because viewers would never have seen it [FIGURE 53].

Like all cast bronzes, the Getty statue is a copy of its wax working model. The interior of the bronze yields much information about how the wax was applied to the master molds, about how the statue was sectioned for casting, and about how those waxes were prepared for casting. Thin sheets of warmed wax, about 4 mm thick, were applied within the master molds for the body and upper legs of the statue; many of the joins between those sheets are clearly visible as dark lines on the X-radiograph, but whether they are on the front or back of the statue is difficult to discern here, and it is helpful wherever possible to look for them inside the bronze itself. A few drips and puddles of wax are also recorded on the inner surface of the bronze [FIGURE 54].

X-radiographs record a peculiar feature of the Getty bronze, in the form of thirty-six or more squares, all measuring about 2 × 2 cm. They appear as dark outlines with about the same intensity as the lines marking the edges of the sheets of

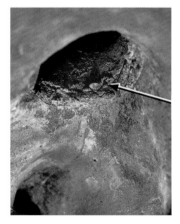

Metalurgical join
between
head and body.

Figure 52
The Victorious Youth.
Photograph of interior
and detail of X-radiograph
of bronze showing join
between head and body.
Photo courtesy of Jerry
Podany.

wax [see FIGURE 51]. The squares have been the subject of numerous discussions, but we have not yet come to a satisfactory explanation of what they are. Outlines of only a few of the squares can be found on the interior of the bronze [see FIGURE 54], and the bronze in the squares is of the same alloy as the surrounding bronze. Indeed the bronze surface of the statue does not reveal any of these squares.[61] In contrast, many of the small repairs or patches set into rectangular cut-outs in the surface of the bronze are fairly easy to see [FIGURE 55].

Squares similar to those in the Getty bronze, but apparently projecting, have been identified on the insides of only about three other ancient bronzes so far. One interpretation is that they are the cast evidence for wax bosses that were added to the working models so as to be able to register them precisely against the clay core and to allow exact replacement of the waxes after their removal while the clay core dried.[62] But the squares visible on the inside of the Getty bronze do not project.

Modern bronze casters offer another interpretation. Could the squares on the Getty statue mark the locations of gates? Archaeologists have always thought that ancient gates were round, not square. But modern founders often use square gates, for two reasons: both because the vortex created when molten bronze is channeled through round gates sucks in more atmospheric gas and yields a more porous, flawed casting; and because gates are made by slicing strips through flat slabs of wax,

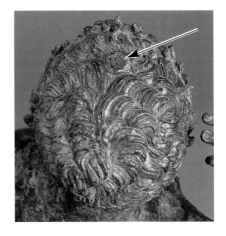

Figure 53
The Victorious Youth. Top of head, with arrow pointing to gate.

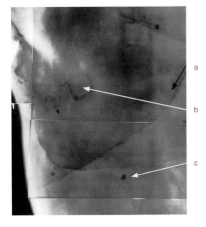

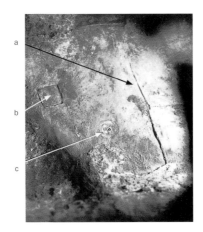

Figure 54
The Victorious Youth. Detail of X-radiograph and photograph of interior showing joins of wax sheets (a), squares (b), and chaplet holes (c). Photo courtesy of Jerry Podany.

Figure 55
The Victorious Youth.
Ancient patches repairing
a crack above the right
hip that occurred during
casting.

Figure 56
The Victorious Youth.
Interior: chaplet hole with
flaring edges. Photo cour-
tesy of Jerry Podany.

which automatically squares them.[63] If indeed the squares mark the locations of gates, then they could represent the points at which wax rods forming the gate system were attached to the outside of the wax working model. For them to be visible as they now are in the X-radiographs would have called for cutting through the working model, then securing the gates by heating the outer surface of the wax around them. Perhaps the dark outlines visible in the X-radiographs record the inner edges of square gates, the outer edges having been melted so as to blend with the wax working model. Such a process seems unnecessarily complicated, however tempting it is to relate these squares to the gate system.

More than twenty small square holes with edges projecting inward mark where rectangular chaplets were pushed through the wax into the core [FIGURE 56]. Bits of the chaplets have been found in the core material. They are short tapering iron nails with small heads, whose function would have been to hold the core in place after the wax was melted out and while the bronze was being poured [see FIGURE 48f].

JOINS

The Getty bronze consists of four separately cast pieces—the head, the arms, and the body with the legs. Separately cast pieces of statues were normally joined by pouring molten bronze into oval depressions cut along the exterior of the juncture between two previously cast components. The degree of metallurgical fusion, and thus the strength of the joins, is determined by the heat achieved during the pour and by the alloy of the bronze used for the flow welds. A chain of oval shapes visible along

the line of a join is the record of these flow welds. X-radiographs of the head and neck of the Getty bronze clearly show the line of a metallurgical join encircling the neck, and a look inside the statue with the aid of an endoscope reveals splatters of bronze solder that congealed along this join [see FIGURE 52]. The neck is unusually thick and cylindrical: is it the result of careless or unskilled workmanship [see FIGURE 39]?

The arms broke off close to their original joins just below the shoulders [see FIGURES 18, 38, 44]. Faint traces of flow-welded joins are visible here on the exterior of the bronze. Indeed the lack of clarity in the modeling of the flexed right biceps may be the result of a somewhat infelicitous match between the body parts chosen for this statue. The biceps looks as if it is turned too far forward, and it corresponds incorrectly with the position of the forearm. One might well wonder whether the upper arm would have been more anatomically convincing had it been attached at a slightly different angle. The breaks in the statue's lower legs are not at joins, but simply at the narrowest and weakest points.

Finishing the Statue

Inserted eyes were important to the naturalistic effect of a bronze. Thus the eye sockets of the Getty bronze were left empty when the statue was cast, and the eyes were inserted after casting. The iris and pupil were probably made of stone or glass, and the white of glass, bone, or ivory. Each eye was fixed in an envelope of reddish sheet copper, its edges cut and curled into lashes [see FIGURE 27].

The Alloy

Pliny wrote that "the proper blend for making statues is as follows . . . at the outset the ore is melted, and then there is added to the melted metal a third part of scrap copper, that is copper or bronze that has been bought up after use" (34.97). Modern foundries still use a similar recipe. Lead is a component of many classical bronzes, whatever their date: lead, like tin, lowers the melting point of the alloy and increases the fluidity of the molten bronze during casting. Lead also promotes fusion when separately cast sections of a statue are welded together.[64] Concentrations range from 0.1% to 20% and seem to depend upon the availability of raw materials and upon the preference of particular workshops.

The Getty bronze is relatively unusual in that the alloy does not contain a measurable amount of lead. Six samples of the metal were tested in 1996, one from a leaf in the wreath, the others from the body and from one of the curious squares.[65] The average copper content is about 88.6%, and the tin content averages 11.3%. The lead was less than 0.1% in all samples. There was approximately 0.1% of cobalt in each sample, and 0.15–0.17% of arsenic in five samples. These traces are of no particular relevance in themselves, but they can be used to link alloys to a single workshop or to a single source of metal (see herms, p. 65).

THE CORE

A large quantity of clay core material was removed from the Getty bronze when it was cleaned in 1971 and 1972.[66] Most of the core consists of loose gray-to-buff marl (clay mixed with fine calcareous fossil matter). The first and darkest layer that was applied to the inside of the wax working model is very fine and compact, about 1.5–5 mm in thickness, with some fine pulverized charcoal added. Since much of the organic material is not charred, the inner core evidently did not reach a very high temperature during baking and pouring. This marl contains pulverized charcoal, tiny fossils and small stones, olive pits and stems, a grape seed, nut shells, leaves, twigs, bits of bone and possibly eggshells, as well as charred reed and grass fibers, iron nails, bronze pins, a nondescript pottery sherd, and a bronze patch.

Fibers were also added to the core, perhaps as binder and also to reduce shrinkage and cracking. The impressions left behind have served to identify them as woven (S-twisted, Z-plied) bast fibers. They could be threads woven from hemp, stinging nettle, or flax. One expert believes that they are likely to be flax — that is, linen — but another is not certain that this is the case. We should not forget Pausanias's assertions that Elis was the only place in Greece where flax was grown (see pp. 42 and 51), which could strengthen the supposition that the Victorious Youth was cast in or near Olympia.

CARBON 14

Carbon-14, or radiocarbon, dates for the Getty bronze were obtained from four samples of organic material (including two olive pits) from the clay core of the statue. The dates that were established suggest that the statue was cast some time between the second quarter of the fourth century B.C. and the beginning of the second century B.C.

These scientifically fixed dates do not help to resolve the art-historical debate about chronology, and it is a sign of the dependence of one discipline upon another that the scientist who ran the radiocarbon tests remarked: "If . . . *stylistic* [my italics] considerations show a consistency with one possible age but not the other, then the simplest thing would be to accept the range that makes more sense."[67] In other words, though these radiocarbon dates leave open the possibility that the statue was cast as early as the fourth century B.C., it is clear that the question of the date of the Victorious Youth cannot be resolved by scholars within any one discipline. Stylistic dating cannot provide the answer here, however, partly because of differences in interpreting the evidence, but even more so because two or more styles could exist at the same time. In fact, as we have seen, works in any one style could continue to be produced for as long as they were in demand.

Modern Views of the Victorious Youth

W e have looked at the wrecks of ancient ships that were carrying statues when they went down, at the places in ancient cities and sanctuaries where the statues once stood, and at ancient private collectors. Having reconstructed the ancient contexts for installation, removal, and resale, we shall now look at the Getty bronze as it is seen today—by museum visitors, by students of Greek art, by specialists in Greek sculpture, by artists, and by doctors. How do we view this ancient statue, which has come such a great distance, over time and over space, to reach its present home?

Any modern scholar studying the Getty bronze will cover the familiar stylistic questions of identification, date, and authorship. By convincing other scholars to accept our own stylistic attributions, we build a reputation in the field, and perhaps either increase the value of a "work of art" or justify its cost. In contrast, the observations of first-time viewers of classical art reflect no such self-interest. Their impressions are distinguished by direct observations and by unbiased opinions, and they are unlikely to have a vested interest in the object.

The youthful victor was a widely popular type of statue throughout antiquity, and a naturalistic style was adopted for all such statues relatively early in the fifth century B.C. The sinuous body, the raised hip, and the sleek, youthful anatomy can best be described as the hallmarks of a broad universal style, developed by fifth-century Greeks and successful as the canonical expression of classical values for two-and-a-half millennia. But the very longevity of this style makes it extraordinarily difficult to evaluate—we cannot agree about dates for such statues, or about authorship. The ancient literary testimonia refer to some of the most famous classical sculptors, but the names of the artists have almost never been found together with statues. Because so few bronze statues survive from antiquity, our opinion of them is very high. Almost none can be dated from independent archaeological or epigraphical evidence, that is, on any basis other than style. Thus the scholarly tendency has been to treat each one as if it were a unique creation and to wonder which famous artist might have made it.

The discovery of a classical bronze statue instantly sparks enthusiasm. Art historians can contribute to the notoriety and to the perceived value of a new find by suggesting the date of its production and by attributing it to a famous artist. For example, the over-life-size statue of a god from Artemision [see FIGURES 7, 8] has been called successively the work of Onatas, of Kalamis, and of Myron, all major artists whose (lost) works are dated to the second quarter of the fifth century.[68] When the two Riace Bronzes were found off the coast of Calabria in 1972, the debate was even livelier. The Riace Bronzes have been attributed to Onatas, Myron, Pheidias, and Polykleitos, to the school of Pheidias, and to a follower of Polykleitos.[69] It is perhaps for reasons of national pride that negotiations were apparently conducted to include them in a major exhibition of ancient Greek art from the western colonies (Magna Graecia), located in what is now modern Italy.[70]

THE SCHOLARLY DEBATE

The sculptor Lysippos was one of the best-known artists of classical antiquity, to judge from the ancient testimonia about his works. During his prolific career, which spanned most of the fourth century, he made portraits of famous people, among them Alexander the Great and some of his friends—and he made some unusual works. Most of his statues represented nude males, which Pliny characterizes as having small heads; carefully rendered hair; and thinner, leaner bodies, appearing taller than was the norm. Lysippos's bronze statue of the *Apoxyomenos* (see p. 60), was brought to Rome by Marcus Agrippa, probably after he helped Octavian to victory at Actium in 31 B.C. The statue stood in front of Agrippa's public baths until Emperor Tiberius had it moved to his own bedroom; the ensuing public outcry forced him to return it. We can compare such devotion with the ecstasy inspired by the Riace Bronzes when they first went on display in Florence, then in Rome, and finally in the local museum of Reggio Calabria [see FIGURES 13, 14].[71]

We can only guess at what exactly the works of Lysippos really looked like and what made them so popular among the Romans. Stories about his statues make us as eager to find a Lysippan bronze as we are to identify a new work by Michelangelo. Pliny reports that Lysippos was famous for having brought something new to the concept of *symmetria* (proportion), which apparently allowed him to represent people not as they were but as they appeared. There was subtlety in even the smallest

details of his statues (34.61–65). To a modern audience, Pliny's remarks suggest many possible interpretations, and the passage has sparked endless scholarly debate. Though not a single statue signed by Lysippos survives, every survey of Greek art deals in some way with his art.

A brief survey of the Getty Museum's own publications on the Victorious Youth exemplifies the way in which scholars have dealt with the question of attribution. In a booklet about the statue published in 1978, Jiří Frel saw the spirit of Lysippos in the statue but admitted that there are no incontrovertible originals by that artist.[72] A year later, Frel unhesitatingly called the statue a late work by Lysippos, made in about 320 B.C., and suggested that it had been part of a group intended for an architectural setting, for the back of the figure was not as subtly executed as the front.[73] In another museum publication written at about the same time, the statue was called a work of Lysippos made between 320 and 310 B.C. and representing a Hellenistic prince as an Olympic victor.[74] Frel tried to place the young man in the family of one of Alexander the Great's successors. At first he saw a resemblance between the Victorious Youth and a head thought to be a portrait of Demetrios Poliorketes (336–283 B.C., king of Macedon 294–288), but he then identified the Getty bronze with a marble portrait herm of the same (now unnamed) individual, the herm representing him as being twenty to thirty years older.[75]

Neither of these identifications survived the skepticism of other scholars. A decade later, the Getty Museum *Handbook* dated the bronze in the fourth-to-third century; an edition published a few years later returned it to the late fourth century.[76] Both editions refer to Lysippos as the possible inspiration for statues of this type but make it clear that the artist of the Getty bronze is unknown.

Not until the 1990s was the next attempt made to identify the statue, and the name was not proposed by the Getty Museum. Instead, much of the scholarly debate has turned to the rendering of the statue's anatomy, its date, and its authorship. The many opinions that have been offered about the Victorious Youth illustrate the uncertainties of stylistic assessment and the difficulty of reaching a consensus. Most arguments center upon the issue of whether or not the bronze is by Lysippos.

Very few scholars insist that the bronze is a Greek original made by Lysippos. Those who do tend to follow the line of thinking presented in the early publications of the work. Thus the statue has again been identified as a youthful successor of Alexander, but now he is Seleukos Nikator (358–281 B.C.) at the age of about

fifteen. The stance, the three-dimensionality, and what is termed a Peloponnesian handling of the anatomy are used to pinpoint the work as a Lysippan original of approximately 340 B.C. Affinities are seen with other works said to be by Lysippos, particularly images of Alexander and Herakles, but the comparanda are not "original" large-scale bronzes. One of the most frequently cited parallels is a bronze statuette in the Musée du Louvre in Paris, acquired in Egypt in the mid-nineteenth century; it is reputed to be a copy of the statue of Alexander bearing a lance, a particularly well-known work by Lysippos [FIGURE 57].[77] Most of the parallels for the Getty bronze are marble, not bronze, and most of them, except for the Agias at Delphi [see FIGURE 30], come from contexts that are surely Roman in date. Was the Getty bronze part of a group, with another statue standing to his left? The least controversial proposal is that because of the strong calves he must be an Olympic runner, who once cradled the victor's palm branch lightly in his left arm.[78]

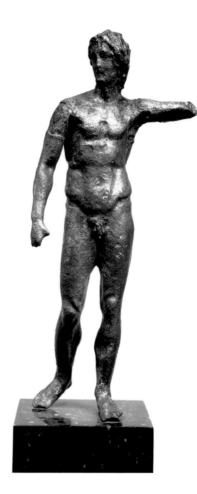

Many scholars now shy away from specific attributions and identifications. Instead, they describe this statue more broadly as Lysippan or post-Lysippan. The more circumspect define the style as falling within the classical tradition (fifth century) but at the same time being either classicizing or having the complexity of the early Hellenistic period. All agree that this is a statue of a victor. Nobody questions, as we did (see p. 50), that the wreath is of olive leaves, but scholars do ask whether the youth is taking it off to dedicate it, or placing it on his head at the presentation ceremony in Olympia. Two writers refer to his having once held a palm branch in his left hand, and a third claims that there are actually traces of the palm. One thinks that this must be a young runner. Another observes that he is not full-grown, and a third thinks that only the body looks youthful, while the head is that of a mature man. Yet another notices that the face looks older from the side than from the front. Despite subtle differences based upon interpretations of the anatomy, there is relatively close agreement that the date of production was between the late fourth century and the middle of the third century B.C.[79]

Figure 57
Statuette of Alexander the Great, after a type of the fourth century B.C. Acquired in Egypt in 1852. Bronze, height 16.5 cm (6½ in.). Paris, Musée du Louvre (BR 370). Photo: Cliché des Musées Nationaux, M. Chuzeville.

Visitors to the Getty Museum and students in art-history classes ask questions and make observations that quickly reveal their interest in the Getty statue. Their participation in the dialogue about the statue contains elements that are lacking from the scholarly debate, and we have much to learn from the questions themselves. Their responses to the statue are not couched in the language of connoisseurship.[80] Visitors and students express very few preconceived notions about classical art. Museum visitors often circle the gallery before pausing in front of the statue; many do not read the label. They want to know why he is naked. They wonder who he is, and they cannot decide whether he is scratching his head or thinking. To some of them, the head seems too small. Most think he looks fit, but not particularly muscular. His mood is more difficult to determine. One visitor thinks he looks unstoppable, but others think he looks effeminate, and one jokingly asks if this is the artist's boyfriend. A chiropractor credits the artist with a good understanding of anatomy, saying that this young man is compact and powerful, with average muscle development from conditioning.[81] A pediatrician might be heard to observe that the penis and pubic hair are those of an adult, but the pubic hair is distributed more narrowly, as if belonging to a fifteen- to eighteen-year-old.

Visitors never understand the gesture, perhaps because few people notice the wreath, which may once have been highlighted in some way but is now hardly visible. In fact, the fingers of the raised right hand would probably have touched the wreath before the leaves corroded and broke.[82] Today, students ask if he is pointing to his head, or if he is about to touch it. Is he scratching, puzzled, confused? Maybe he is waving to a crowd after his victory, or flexing his biceps to show off his muscles. An artist remarks that *he* would have adjusted the arm differently.

That the expression is described in many different and conflicting ways is a sign of the uncertainties of subjective analysis. Is he serious, proud, confident, calm, relaxed, thoughtful, fatigued, confused, or unemotional? One student thinks that the meaning of the facial expression should have been explained on the label. Another asks whether the eyes were meant to be empty, as now they are. To one student, the statue is sad and soulless without eyes. Another sees "a blank stare in the eyes" as normal for Greek sculptures. And a third adds, "I've always hated those blank-looking holes for eyes. Maybe I'm supposed to imagine some expression on my own?"

Like scholars, students are particularly interested in the identity of the statue, but they allow more latitude in their definitions. He is a god, a hero, an aristocrat, a warrior, a coach, or an athlete. One thinks that a victorious athlete should be wearing athletic gear, but others respond that nudity was appropriate for an athlete in ancient Greece, and that the statue was sculpted at a time when there was artistic freedom to expose the body.

Scholars excepted, everyone refers to the Getty bronze as "naked" rather than nude. One student disapproves, but most viewers willingly discuss the anatomy. Those who notice that the statue is labeled as a victor wonder what kind of victor. They all see him as a healthy young man, anatomically correct, well proportioned, muscular, and in excellent physical shape. Some describe him as idealized. But one person says that he has a small penis, another that the arms are either too long or too skinny. (Are the missing lower legs and feet the reason for this perception?)

Does the statue's face look too young for his body? Or is the reverse true? Both opinions are expressed. Either the raised hip is meant to be a signal, or the statue simply has that "lean" to it that is common in Greek sculptures. In marked contrast to the scholarly dialogue, students and visitors tend not to be more specific about the date than to say that the statue is classical. They compare it to the Belvedere Apollo, to Donatello's *David*, and to Michelangelo's *David*.

Some students muse about technology. One asks how bronze could be given such a realistic form, and another wonders what it could have been like to make this statue from bronze.

Students do not understand the statue's condition. Some recognize that the bronze is weathered from burial or from submersion in water, but one honestly thinks that the young man has a bad skin condition. Several ask what happened to his feet. Did they break off or has he been injured in a sporting event, leaving him with stumps? Maybe we have forgotten to describe the statue's modern history to our students and to tell them that the bronze was found in the sea.

A visitor to the museum, however, will probably not ask all of these questions, but all ask some of them, even the person who walks into the gallery, snaps a picture of the statue, and departs, trusting her experience of the Getty bronze to the vagaries of her own skill with the camera.[83]

Reaching a Consensus

Figure 58
Relief from Cape Sounion,
early fifth century B.C.
Found in 1915 near the
Temple of Athena. Marble,
height 48 cm (18⅞ in).
Athens, National Archaeo-
logical Museum (3344).

Ever since its discovery in the sea, the bronze statue now in the Getty Museum has exerted a powerful visual impression. And yet our interpretations of the face, the body, and the gesture may all differ. After listening to how others express their interests, we may find ourselves noticing points that we have never seen before. Certainly the loss of the feet affects our impression of the statue's proportions. And wouldn't we see the expression very differently if lifelike eyes were still in place, as they are in the Delphi Charioteer [see FIGURE 29]? Even then, could we all agree about the expression?

Scholars know this type of figure well—the victorious athlete, the *auto-stephanoumenos* (hand raised to the wreath as if he is crowning himself). A marble relief found at Cape Sounion in 1915 may have been a dedication to Athena. Early fifth century in style, it shows a youth with bent head and right hand reaching toward a wreath on his head whose leaves were separately attached, maybe in bronze [FIGURE 58]. A slender prepubescent marble boy from Eleusis has lost both his arms, but the pronounced lift of his right shoulder and his ducked head leave little doubt that he too is an *autostephanoumenos*. The date is uncertain [FIGURE 59].[84] Another marble youth,

Figure 59
Statue of a boy from
Eleusis. Marble, maxi-
mum present height
1.03 m (40½ in.).
Athens, National Archaeo-
logical Museum (254).

Figure 60
Unfinished carving of
youth with palm branch,
found in the late nine-
teenth century near the
Dipylon Gate in Athens.
Marble, height 1.48 m
(58¼ in.). Athens,
National Archaeological
Museum (1662).

right hand again raised to a wreath, cradles a palm branch against the left arm just as
the Getty bronze may have done. This unfinished carving, probably Roman in date,
was found in the late nineteenth century near the Dipylon Gate in Athens, and may
have been destined to serve as a funerary monument [FIGURE 60].

Another fit young nude in a confident stance is represented in a bronze
statuette from the first-century-B.C. Antikythera shipwreck. The figurine is still
attached to a red stone base, but the right arm is missing, as is whatever the young
man may have held in his left hand; he wears no wreath. In their treatment of this
statuette, scholars refer to the fourth century and to Lysippos [FIGURE 61].[85]

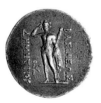

When this type of figure is removed from the sphere of Greek athletics, it serves equally well as Herakles. A coin struck in second-century-B.C. Bactria has on the reverse a slender nude image of Demetrios I crowning himself with one hand and holding not a palm branch but a club in the other, a lion skin draped over his lower arm [FIGURE 62].[86]

The familiar *autostephanoumenos* also appears in Roman wall frescoes: in one painting he is an actual athlete with a palm branch in his hand, fixing a wreath upon his head [see FIGURE 42]. In another he is illustrated as a statue of an athlete holding either a long leafless palm branch or a lance in one hand, the other hand raised to his wreath.[87]

As for the problems that scholars have addressed— date, place, authorship—we have no way of knowing whose work this statue is. But perhaps we can draw some conclusions about the "originality" of the Getty bronze from examining carefully how it was designed, cast, and put together. We may also come closer to establishing its provenance by taking a very close look at the materials in the clay core of the statue.

A few early notions about the statue's appearance based upon inaccurate physical observations can now be discarded. It was suggested that the neck is too long and cylindrical and that the right arm is oddly positioned because both the wax and the clay core were adjusted before casting.[88] In fact, as we saw in the previous chapter, a full-scale hollow-wax image was the actual working model for a bronze statue, and it would have been adjusted, detailed, and embellished as a matter of course. Furthermore, the clay core material within the edges of each separately cast section of a statue was normally altered when the sections were joined by flow weld- ing. The Victorious Youth is typical of ancient Greek bronze statues in that the head down to the middle of the neck and both arms from just below the shoulders were separate castings [FIGURE 63; see also FIGURES 38, 52]. Indeed, the outward appearance of the area around all three of these joins suggests simply that the indi- vidual who integrated the various body parts either worked somewhat carelessly or was not as highly skilled as some of the other specialists involved in the original production of this statue.

Figure 63
The Victorious Youth.

Figures 64, 65
Two statues shown on the Berlin Foundry Cup, early fifth century B.C. Berlin, Staatliche Museen zu Berlin—Preußischer Kulturbesitz, Antikensammlung (F 2294). Photo: Ingrid Geske-Heiden.

Scholars are increasingly wary of stylistic dating of ancient sculpture. Nobody would doubt that two or more types of statues could be popular at any given date, but we used to think that these types were all of a single style, and we dated them by their styles. We now have clear evidence that this idea of progression cannot be trusted. A single style can be popular for a long time, coexisting with other "newer" styles, or historical interest can lead to the revival of an old style in a much later period.

From at least the early fifth century B.C. onward, more than one style of statue was being produced. The Archaic style continued beyond what we have traditionally called the Archaic period—broadly, the sixth century B.C.—alongside a more naturalistic style, which we call "Classical" and whose inception we date to the fifth century. On an Attic cup in Berlin depicting a bronze foundry, a colossal statue of a striding warrior is represented with a frontal torso, and with head, arms, and legs in

profile [FIGURE 64]. This "Archaic" rendering contrasts sharply with another statue illustrated on the same cup. The second statue has all of the features that we associate with fifth-century athletic statuary: it is life size, and its position and anatomy are just as naturalistic as those used for the human figures represented on the same cup [FIGURE 65].

We rarely have an opportunity like this to see two very different statues that are indisputably within the same context. In fact, our difficulty in recognizing coexisting styles is easy to trace to the nature of the evidence available to us. From the literary testimonia we simply cannot reconstruct the appearance of statues. The archaeological evidence is always incomplete, and we may never find an ancient foundry with statues still in the shop. Nonetheless, there is a growing body of evidence for stylistic continuity and for certain popular styles and types of images. For example, a bronze statue that we would assign to fifth-century Greece for stylistic reasons was actually produced in Colchis, east of the Black Sea, during the second century B.C., with peculiarly painstaking technology that is surely local [FIGURE 66].[89] And for nearly 150 years, scholars debated about the exact date of the supposedly late Archaic Piombino Apollo, only to find that it was probably made during the first century B.C., and that another statue almost exactly like it, and probably from the same production line, was adorning a house in Pompeii at the time of the city's destruction in A.D. 79 [FIGURES 67, 68].[90] Another household ornament, a bronze herm of Dionysos in the Getty Museum, is of a type and style that was popular for at least 150 years, in both bronze and marble editions [see previous chap. and FIGURES 43, 45].

Figure 66
Life-size torso from Vani in ancient Colchis. From a destruction context of the 80s B.C. Excavated in 1988. Bronze, maximum present height about 1.01 m (39¾ in.). Vani Museum. Photo courtesy of Michail Yu. Treister.

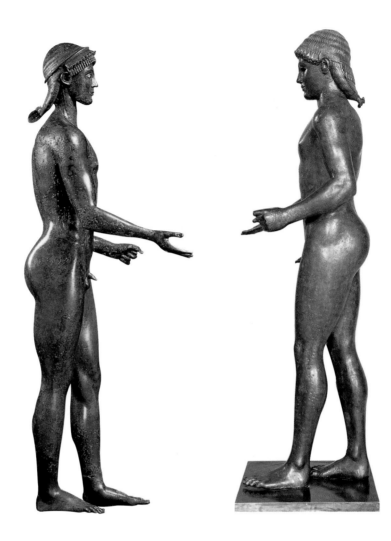

Figure 67
Apollo from the house of C. Julius Polybius at Pompeii. Excavated in 1977. Bronze, height 1.28 m (50⅜ in.). Pompeii (22924). Photo courtesy of "L'Erma" di Bretschneider.

Figure 68
Apollo from Piombino, probably first century B.C. Found in the sea in 1812 or 1832. Bronze, height 1.16 m (45⅝ in.). Paris, Musée du Louvre (Br. 2). Photo: Réunion des Musées Nationaux.

The Victorious Youth was lost at sea, apparently during shipment from Greece to Italy. We can only guess at the date of the loss, but we should probably not be far wrong to look to the period during which Greek sites were being stripped and Roman collections were being so actively built—between the second century B.C. and the second century A.D. The type of the handsome youth was always popular, whether naturalistic or idealized. We need only recall the winged Mahdia Eros, with face and body of a boy, one hand raised to finger a wreath [see FIGURE 6]. A bronze boy from Rhodes may also be an athlete, but his arms and hands were restored during the six-

teenth century as if raised in prayer [FIGURE 69]. Both are probably Hellenistic in date. Although these two have youthful bodies similar to that of the Getty bronze, the other two depict younger boys, to judge from their still-undeveloped genitalia and lack of pubic hair. These two delicate boys, particularly the Eros, are easily understood as products designed as ornaments, not as public works. In contrast, it is as a public presence, as a victory monument, probably of the third or second century B.C., that the Victorious Youth reads most clearly.

NOTES

References to classical authors are generally given in the text; the following translations are used unless otherwise noted:

CICERO. *Letters to Atticus*, trans. E. O. Winstedt. Loeb Classical Library (1980).

PAUSANIAS. *Description of Greece*, trans. W. H. S. Jones. Loeb Classical Library (1966).

PLINY. *Natural History*, trans. H. Rackham. Loeb Classical Library (1967).

1 For additional information from Willard Bascom, and for an overview of the history of underwater archaeology, see Peter Throckmorton, ed., *The Sea Remembers: Shipwrecks and Archaeology* (New York, 1987).

2 Quoted by Throckmorton (see n. 1), p. 14. This wreck is published in P. C. Bol, *Die Skulpturen des Schiffsfundes von Antikythera*, Mitteilungen des Deutschen Archäologischen Instituts, Athenische Abteilung, Beiheft 2 (Berlin, 1972). See also Gladys Davidson Weinberg et al., *The Antikythera Shipwreck Reconsidered*, Transactions of the American Philosophical Society, n.s., vol. 55, part 3 (Philadelphia, 1965).

3 See N. Yalouris, "The Shipwreck of Antikythera: New Evidence of Its Date after Supplementary Investigation," ΕΥΜΟΥΣΙΑ: *Ceramic and Iconographic Studies in Honour of Alexander Cambitoglou*, ed. Jean-Paul Descoeudres (Sydney, 1990), pp. 135–36.

4 For a review of the scholarship on this statue, see Magdalene Söldner, "Der sogenannte Agon," in Gisela Hellenkemper Salies et al., eds., *Das Wrack: Der antike Schiffsfund von Mahdia* (Cologne, 1994), vol. 1, pp. 399–429. For the herm, see Carol C. Mattusch, "Bronze Herm of Dionysos," in ibid., pp. 431–50.

5 *Greek Anthology*, 9.440, trans. W. R. Paton. Loeb Classical Library (1925).

6 New work is currently in progress on the wreck, on the horse, and on the god. See Willard Bascom, "The Poseidon Statue Wreck," and Séan A. Hemingway, "Reexamining the Bronze 'Horse and Jockey Group from Artemision,'" Abstracts from the 97th Annual Meeting of the Archaeological Institute of America, *American Journal of Archaeology* 100 (1996): 368; and Olga Tzachou-Alexandri, "Some Remarks on the Bronze God of Artemision," forthcoming in Carol C. Mattusch, ed., *Acts of the 13th International Bronze Congress*, supplement to *Journal of Roman Archaeology*.

7 See Peter G. Calligas, "Statue of a Young Athlete," in Olga Tzachou-Alexandri, ed., *Mind and Body: Athletic Contests in Ancient Greece*, exh. cat. (Athens, 1989–1990), no. 71, pp. 179–80.

8 In fact, the "Archaic" statue of Herakles represented on the Roman relief in Ostia wears a breastplate (see fig. 9).

9 The foremost publication on the statues is *Due bronzi da Riace: Rinvenimento, restauro, analisi ed ipotesi di interpretazione*, 2 vols., Bolletino d'Arte, serie speciale 3 (Rome, [1984]).

10 Luigi M. Lombardi Satriani, in idem and Maurizio Paoletti, eds., *Gli eroi venuti dal mare / Heroes from the Sea* (Rome, 1986), p. 126.

11 See John Perrotta, "The Riace Bronzes: Rusty Gifts From the Sea," *The Wall Street Journal*, April 8, 1993, A12.

12 For a dramatic account of the statue's alleged history up to this point, see Bryan Rostron, "Smuggled!" *Saturday Review*, March 31, 1979, pp. 25–30.

13 For an analysis of the clay core material, see p. 76.

14 Jiří Frel, *The Getty Bronze* (Malibu, 1978).

15 Jerry Podany, Antiquities Conservator at the Getty Museum, kindly provided the information about the weight of the statue, which is now slightly greater than it would have been during antiquity because of the modern mount and the resin inside the statue that secures it.

16 For further discussion of the bronzes, see Carol C. Mattusch, *Classical Bronzes: The Art and Craft of Greek and Roman Statuary* (Ithaca, NY, 1996), pp. 129–40. The bronzes will be fully published by Olga Palagia, "Reflections on the Piraeus Bronzes," in eadem, ed., *Greek Offerings to Sir John Boardman* (Oxford, forthcoming).

17 See Plutarch *Alexander* 4.1; idem *De Alexandri Magni fortuna aut virtute* 2.2.

18 Dio Chrysostom, *Discourses*, 31.8–10, trans. J. W. Cohoon and H. Lamar Crosby. Loeb Classical Library (1940; reprint 1979).

19 Plutarch makes this allegation in *Life of Themistokles* 1.

20 For discussion, see Carol C. Mattusch, "The Eponymous Heroes: The Idea of Sculptural Groups," in W. D. E. Coulson et al., eds., *The Archaeology of Athens and Attica under the Democracy*, Oxbow Monograph 37 (Oxford, 1994), pp. 73–81.

21 Thucydides 6.53–59.

22 See Sture Brunnsåker, *The Tyrant-Slayers of Kritios and Nesiotes: A Critical Study of the Sources and Restorations*, 2nd edn. (Stockholm, 1971).

23 Plaster casts from this workshop, which was in operation from the end of the first century B.C. to the early second century A.D., represent many well-known statues. They are on exhibition in the Castello di Baia. See Christa Landwehr, *Die Antiken Gipsabgüsse aus Baiae: Griechische Bronzestatuen in Abgüssen römischer Zeit* (Berlin, 1985).

24 Pliny 34.8. Studies of the Riace Bronzes have shown that their skin was perhaps once black. See Hermann Born, "Patinated and Painted Bronzes: Exotic Technique or Ancient Tradition?" in Marion True and Jerry Podany, eds., *Small Bronze Sculpture from the Ancient World*,

Papers Delivered at a Symposium Organized by the Departments of Antiquities and Antiquities Conservation and Held at the J. Paul Getty Museum March 16–19, 1989 (Malibu, 1990), pp. 179–96; and Mattusch (see n. 16), pp. 24–29, with additional bib.

25 Plutarch *Quaestiones convivales* 5.1.2.

26 Lucian *Zeus Tragoidos* 33. Pausanias also mentions that the statue is on the way to the Painted Stoa (1.15.1).

27 See F. W. Imhoof-Blumer and Percy Gardner, *Ancient Coins Illustrating Lost Masterpieces of Greek Art: Numismatic Commentary on Pausanias* (1885; reprint, Chicago, 1964), pp. 125–52.

28 For further discussion and bib., see Carol C. Mattusch, *Greek Bronze Statuary: From the Beginnings through the Fifth Century B.C.* (Ithaca, NY, 1988), pp. 168–72.

29 Dionysius of Halicarnassus *De Isocrate* 3.

30 James M. Goode, *The Outdoor Sculpture of Washington, D.C.: A Comprehensive Historical Guide* (Washington, D.C., 1974).

31 Pindar, from *Pythian Ode* 8, 446 B.C. Frank J. Nisetich, trans., *Pindar's Victory Songs* (Baltimore, 1980), p. 204.

32 See Pausanias 10.13.9; Herodotos 9.81; Thucydides 1.132; Werner Gauer, *Weihgeschenke aus den Perserkriegen*, Mitteilungen des Deutschen Archäologischen Instituts, Abteilung Istanbul, Beiheft 2 (Tübingen, 1968), pp. 75–96; discussion and bib. in Mattusch (see n. 28), pp. 96–97.

33 Pausanias 5.5.2 and 7.21.14. For an extensive commentary on the flax of Elis, and on the uses of linen in the ancient world, as well as on some writers' confusion of cotton with flax, see J. G. Frazer, *Pausanias's Description of Greece* (1897; reprint, New York, 1965), vol. 3, pp. 470–74. Indeed, the production of flax in the southwestern Peloponnesos is attested in the Linear B tablets of Mycenaean times. See John Chadwick, *The Mycenaean World* (Cambridge, 1976), pp. 153–56, 160.

34 From Gustave Flaubert, *Voyage en Orient 1849–1851*. Quoted from Fani-Maria Tsigakou, *The Rediscovery of Greece: Travellers and Painters of the Romantic Era* (New Rochelle, NY, 1981), p. 168.

35 For a discussion of these monuments, see Walter Woodburn Hyde, *Olympic Victor Monuments and Greek Athletic Art* (Washington, D.C., 1921).

36 Pausanias 1.44.1. For the Olympic Games in antiquity, see Nicolaos Yalouris, ed., *The Eternal Olympics: The Art and History of Sport* (New Rochelle, NY, 1979); Judith Swaddling, *The Ancient Olympic Games* (London, 1980); Tzachou-Alexandri (n. 7); Elsi Spathari, *The Olympic Spirit* (Athens, 1992); and Doris Vanhove, ed., *Le Sport dans la Grèce antique: Du jeu à la compétition*, exh. cat. (Brussels, 1992).

37 Plutarch *Moralia* 274D–E: "The Romans viewed oil rubdowns with extreme suspicion, and they think that there is no greater cause of the slavery and effeminacy of the Greeks than their *gymnasia* and *palaistrai*, which breed much useless idleness and indolence and paederasty in their cities. The bodies of young men are eroded by sleep and strolls and rhythmical movements and exact diets," trans. Stephen G. Miller, *Aretē: Greek Sports from Ancient Sources*, 2nd edn. (Berkeley, 1991), pp. 18–19; for additional passages and discussion, see pp. 17–20; and Waldo E. Sweet, *Sport and Recreation in Ancient Greece: A Sourcebook with Translations* (New York, 1987), pp. 124–33.

38 Runner—Olympia B 26, height: 10.2 cm; from northwest of the stadium at Olympia. Diskos thrower—Olympia B 6767, height: 9.5 cm; from the southeast region of the sanctuary. Horse—Olympia B 1000, height: 22.8 cm. See Alfred Mallwitz and Hans-Volkmar Herrmann, eds., *Die Funde aus Olympia: Ergebnisse hundertjähriger Ausgrabungstätigkeit* (Athens, 1980), pp. 156–57, 159, pls. 107, 111.

39 Flutist—Delphi Museum 7724, height: 16.9 cm. For the bronzes in Delphi, see Claude Rolley, *Monuments figurés: Les statuettes de bronze*, Fouilles de Delphes, vol. 5 (Paris, 1969).

40 I am grateful to Dr. J. Kenneth Bowman, chiropractor, for his observations.

41 Abraham M. Rudolph et al., eds., *Rudolph's Pediatrics*, 19th ed. (Norwalk, CT, 1991), pp. 1666–67.

42 See Gerhard Zimmer, *Griechische Bronzegußwerkstätten* (Mainz, 1990).

43 Livy 40.50.3.

44 Pliny 34.36 and 34.30. For commentary on Pliny's approach to his subject, see Jacob Isager, *Pliny on Art and Society: The Elder Pliny's Chapters on the History of Art* (New York, 1991).

45 *Corpus Inscriptionum Latinarum*, vol. 6.2 (Berlin, 1882), p. 1235, no. 9403. I am grateful to A. A. Donohue for this reference.

46 See Diane Harris, "Bronze Statues on the Athenian Acropolis: The Evidence of a Lycurgan Inventory," *American Journal of Archaeology* 96 (1992): 637–52; and Mattusch (see n. 16), pp. 101–2.

47 For a fascinating summary of Roman collections and museum practices, see Donald Emrys Strong, "Roman Museums," in idem, ed., *Archeological Theory and Practice: Essays Presented to Professor William Francis Grimes* (London and New York, 1973), pp. 247–64.

48 J. J. Pollitt, *The Art of Rome: c. 753 B.C.– A.D. 337: Sources and Documents* (1966; reprint, New York: Cambridge Univ. Press, 1983), p. 76 n. 157.

49 Trans. Pollitt (see n. 48), pp. 76–77.

50 Trans. Pollitt (see n. 48), p. 77.

51 Trans. Pollitt (see n. 48), p. 77.

52 Trans. Pollitt (see n. 48), p. 78.

53 Cicero *Epistulae ad Familiares* 7.23.1–3.

54 Pollitt (see n. 48), p. 68: probably $450.

55 Technical observations made during the early 1970s appeared in the earliest publications of the statue by Frel (see n. 14; rev. edn., 1982). These formed the basis for technical remarks by Denys Haynes, *The Technique of Greek Bronze*

Statuary (Mainz, 1992); and for technical and stylistic conclusions drawn by Antonietta Viacava, *L'atleta di Fano* (Rome, 1994); and by Paolo Moreno, ed., *Lisippo: L'arte e la fortuna* (Milan, 1995), with refs. to his numerous previous publications on the subject of the Getty bronze.

New findings allow us to clarify or discard many of these proposals. The physical information about the statue and the results of analyses presented here are all based upon new and thorough examinations and draw upon the significant advances in our understanding of ancient bronze technology resulting from research done during the last twenty-five years. The work summarized here was conducted primarily during 1995 and 1996, by Jerry Podany, Antiquities Conservator at the J. Paul Getty Museum, and David Scott, Senior Scientist, Getty Conservation Institute, Museum Research Laboratory, in the early stages of what is to be a full scientific analysis of the Getty statue. Their preliminary report, "The Getty Youth Reconsidered: An Initial Report on the Scientific and Technical Restudy of the Getty Victorious Youth," will be published in the forthcoming *Acts of the 13th International Bronze Congress* (see n. 6). There, they consider previous theories about the statue and the evidence upon which these theories were based. I am indebted to them for sharing their results with me and for collaborating in the production of this chapter. Discussions with them and with many others about the physical features of the statue have been of great benefit. Marion True, Curator of Antiquities and Assistant Director for Villa Planning at the J. Paul Getty Museum, generously allowed us to remove the statue from exhibition so that we could engage in a dialogue in the laboratory of the Getty Museum.

56 For the testimonia, see J. J. Pollitt, *The Art of Ancient Greece: Sources and Documents* (New York, 1990), pp. 98–104.

57 Mattusch (see n. 4), with refs.; and eadem, ed., *The Fire of Hephaistos: Large Classical Bronzes from North American Collections*, exh. cat. (Cambridge, MA, 1996), pp. 186–91.

58 This latter point proves that neither herm is a copy of the other. Both herms have an unusually high lead content (16–18%) and traces of cobalt in the alloy. These can hardly be accidental mixtures, and it is possible that the two herms were cast from the same batch of metal. The Getty herm has an average of 0.049% cobalt from two samples; and the Mahdia herm averages 0.22% cobalt from eight samples. See Mattusch (n. 57), table p. 173.

59 I am grateful to Frank Willer of the Conservation Department at the Rheinisches Landesmuseum–Bonn for showing me the photographs from the computer tomography done on the Mahdia herm at the Bundesanstalt für Materialforschung und -prüfung in Berlin and for discussing the process with me. Tomography records widely varying thicknesses in the walls of the bronze turban on this head.

60 For a word that may refer to the armature of a statue, see Carol C. Mattusch, "Pollux on Bronze Casting: A New Look at κάναβος," *Greek, Roman and Byzantine Studies* 16 (1975): 309–16.

61 One square that is marked on the outside of the back of the neck was actually outlined in modern times, and though the square appears in the X-radiographs, the nature of its appearance on the exterior of the bronze cannot now be clarified.

62 For this proposal, see Edilberto Formigli, "Note sulla tecnologia nella statuaria bronzea greca del v sec. a.C.," *Prospettiva*, October 23, 1980, pp. 61–66; also idem, "Bemerkungen zur technischen Entwicklung des Gußverfahrens griechischer Bronzestatuen," *Boreas* 4 (1981): 15–24; and idem, in Maria Rita Di Mino and Marina Bertinetti, eds., *Archeologia a Roma: La materia e la tecnica nell'arte antica* (Rome, 1990), pp. 113–16. See also Wolf-Dieter Heilmeyer, *Der Jüngling von Salamis* (Mainz, 1996), pp. 54–56 and figs. 47–54.

Brunilde S. Ridgway disagrees, and so do I: see her "The Bronzes from the Porticello Wreck," in Helmut Kyrieleis, ed., *Archaische und klassische Griechische Plastik*, Akten des inter-

nationalen Kolloquiums, vom 22.–25. April 1985 in Athen (Mainz, 1986), pp. 61–62; and Cynthia Jones Eiseman and Brunilde S. Ridgway, *The Porticello Shipwreck: A Mediterranean Merchant Vessel of 415–385 B.C.* (College Station, TX, 1987), pp. 85–86. Discussions of the problem continue, most recently among Jerry Podany, Jeff Maish, Marie Svoboda, Gerhard Zimmer, Edilberto Formigli, Nele Hackländer, Sandra Knudsen, and myself.

63 I am grateful to Jon Lash of the Johnson Atelier in Mercersville, New Jersey, for the first explanation, and to Thomas Lingeman, Chair of the Art Department at the University of Toledo, Ohio, and his student David J. Eichenberg, for the second one.

64 See Arthur Steinberg, "Joining Methods on Large Bronze Statues: Some Experiments in Ancient Technology," in William J. Young, ed., *Application of Science in Examination of Works of Art* (Boston, 1973), pp. 103–38.

65 Inductively coupled plasma–mass spectrometry (ICP-MS) tests of the alloy were conducted by David Scott, Senior Scientist at the Getty Conservation Institute, Museum Research Laboratory, in January and March of 1996. ICP-MS is a versatile method of testing, which yields precise information about a wide range of chemical elements contained in a bronze alloy. It is most useful for providing measurements of lead and trace elements in the alloy. The preliminary results of the 1996 analyses will be published by Podany and Scott (see n. 55).

 Tests were first done on the statue in 1971 using atomic absorption analysis. The results are relatively close to those of 1996, but can now be replaced by the more accurate and more detailed ICP-MS analyses.

66 I am grateful to Marie Svoboda for providing information on the core and for discussing many aspects of the statue with me. She and John Twilley, Senior Research Scientist at the Los Angeles County Museum of Art, studied the core material in 1995 and 1996. See Marie Svoboda, "Core Material Notes," unpublished paper, J. Paul Getty Museum, August 1996.

 The core has been examined by optical petrography, X-ray diffraction (XRD), and qualitative energy dispersive X-ray fluorescence (XRF). Fibers were analyzed by optical and scanning electron microscopy (SEM), by energy dispersive X-ray spectrometry (EDS), and Fourier transform infrared spectroscopy (FTIR).

67 Electronic-mail message from Rodger Sparks to Jerry Podany, October 3, 1996. Carbon-14 tests were carried out in 1996 by Rafter Radiocarbon Laboratory, Institute of Geological and Nuclear Sciences Limited, New Zealand. With a 95% confidence level, the dates are between 377 and 167 B.C. From Podany and Scott (see n. 55).

68 Onatas—Reinhard Lullies and Max Hirmer, *Greek Sculpture*, rev. edn. (New York, 1960), p. 75; John Boardman et al., *The Art and Architecture of Ancient Greece* (London, 1967), p. 278; Kalamis—Chr. Karouzos, "Ho Poseidon tou Artemisiou," *Archaiologikon Deltion* 13 (1930–1931): 41–104. Myron—Vagn Poulsen, "Myron: Ein stilkritischer Versuch," *Acta Archaeologica* 11 (1940): 41–42.

69 Onatas—P. E. Arias, "Lettura delle statue bronzee di Riace," in *Due bronzi* (see n. 9), pp. 243–50. Myron—Georgios Dontas, "Considerazioni sui bronzi di Riace: Proposte sui maestri e sulla provenienza delle statue," ibid., pp. 277–96. Pheidias—ibid.; Werner Fuchs, "Zu den Großbronzen von Riace," *Boreas* 4 (1981): 25–28; Jiří Frel, "Some Observations on Classical Bronzes," *Journal of the J. Paul Getty Museum* 11 (1983): 117–19. Polykleitos—Antonino di Vita, "Due capolavori attici gli oplitodromi—'Eroi' di Riace," in *Due bronzi* (see n. 9), pp. 251–76. School of Pheidias—Arias, "Lettura." Influence of Polykleitos—Dontas, "Considerazioni."

70 After conservation was done on the two statues in the 1990s, it was reported that they are unique products of the direct lost-wax process and not, as most deduce from the technical evidence, cast by the indirect process with the individualized features introduced directly in the wax working model. For the former opin-

ion, see Alessandra Melucco Vaccaro, "The Riace Bronzes Twenty Years After: Recent Advances after the 1992–1995 Intervention," in *Acts of the 13th International Bronze Congress* (see n. 6).

71 For public response to the statues, see Giulio Cesare Papandrea, *I bronzi di Riace tra storia e leggenda: Culti pagani e fede cristiana nel Mezzogiorno d'Italia* (Rome, 1990); and Lombardi Satriani and Paoletti (see n. 10).

72 Frel (see n. 14), pp. 14–20; Frel, 1982 edn. (see n. 55), pp. 29–44.

73 Jiří Frel, "Antiquities in the J. Paul Getty Museum: A Checklist. Sculpture 1. Greek Originals" (Malibu, 1979), p. 12.

74 Jiří Frel, *Greek Portraits* (Malibu, 1981), no. 25, pp. 72–75.

75 Marble herm—J. Paul Getty Museum 82.AA.133. Frel (see n. 74), pp. 74–75, 113. For a related head in the Smith College Museum of Art (acc. no. 25:8-1), see Phyllis Williams Lehmann, "A New Portrait of Demetrios Poliorketes," *Journal of the J. Paul Getty Museum* 8 (1980): 107–16. Frel (see n. 74), p. 113, also mentions that the olive wreath may have had silver on it, a feature for which there is no physical evidence.

76 *The J. Paul Getty Museum Handbook of the Collections* (Malibu, 1988), p. 42; rev. edn. 1991, p. 32.

77 For references, see Andrew Stewart, *Faces of Power: Alexander's Image and Hellenistic Politics* (Berkeley, 1993), esp. pp. 163–71, 425.

78 For advocacy of Lysippos as the artist, and for theories summarized in this paragraph, see Cornelius C. Vermeule, *Greek and Roman Sculpture in America* (Berkeley, 1981), pp. 88–89; Paolo Moreno, *Vita e arte di Lisippo* (Milan, 1987), esp. pp. 141–52; idem, *Scultura ellenistica*, 2 vols. (Rome, 1994), esp. vol. 1, pp. 5–7, 39, 112, 148–50; Viacava (n. 55), passim, with bib.; eadem, in Moreno (see n. 55), esp. pp. 68–72, with bib. For a succinct summary of *L'atleta*, and for discussion of the methodology, see Elizabeth Bartman, review of Federico Rausa, *L'immagine del vincitore*, and of Viacava, *L'atleta di Fano*, in *American Journal of Archaeology* 101 (1997): 178–79.

79 The observations in this paragraph are drawn from Claude Rolley, *Les Bronzes grecs* (Fribourg, 1983), pp. 42, 227; David Finn and Caroline Houser, *Greek Monumental Bronze Sculpture* (New York, 1983), pp. 110–15; Brian A. Sparkes, "Greek Bronzes," *Greece and Rome* 34 (1987): 159–60; Brunilde S. Ridgway, *Hellenistic Sculpture*, vol. 1: *The Styles of ca. 331–200 B.C.* (Madison, 1990), pp. 57–58; Andrew Stewart, *Greek Sculpture: An Exploration* (New Haven, 1990), pp. 39, 200, 291, 315; R. R. R. Smith, *Hellenistic Sculpture: A Handbook* (London, 1991), pp. 53, 58; Brian A. Sparkes, *Greek Art* (New York, 1991), p. 21; and Federico Rausa, *L'immagine del vincitore: L'atleta nella statuaria greca dall'età arcaica all'ellenismo* (Rome, 1994), pp. 154–55.

80 I am especially grateful to the thirty-two students in my Fall 1996 Greek Art class at George Mason University—for their responses and for helping me think more clearly about ancient sculpture—and to Benedicte Gilman and Elizabeth Burke Kahn for observing, listening, and summarizing remarks made about the statue by visitors to the gallery during August 1996.

81 With thanks to Dr. J. Kenneth Bowman, a chiropractor in Vienna, Virginia, for his opinion, rendered after seeing photographs of the statue.

82 The leaves of the wreath bear no traces of silver, as was once suggested. See Frel (n. 73), p. 12, no. 50.

83 Nancy H. Ramage reported having seen this happen in October 1996.

84 Semni Karouzou, *National Archaeological Museum: Collection of Sculpture. A Catalogue*, trans. Helen Wace (1968; reprint, Athens, 1974), p. 57: early fourth-century Attic sculpture based on a fifth-century Polykleitan Argive original. Paul Zanker, *Klassizistische Statuen: Studien zur Veränderung des Kunstgeschmacks in der römischen Kaiserzeit* (Mainz, 1974), pp. 21–22, no. 17: late second- to early first-century-B.C. copy of an early fourth-century original. Vassilike

Machaira, in Tzachou-Alexandri (see n. 7), pp. 338–39, follows Zanker.

85 Bol (see n. 2), pp. 14–17.

86 For many additional examples of this type of figure with various identities, see Moreno, *Scultura ellenistica* (n. 78), vol. 1, pp. 25–42.

87 For the former, see Eric M. Moormann, *La pittura parietale romana come fonte di conoscenza per la scultura antica* (Assen / Maastricht and Wolfeboro, NH, 1988), p. 238; and Viacava (see n. 55), fig. 4. For the latter, in the House of the Vettii at Pompeii, see Moreno, *Scultura ellenistica* (n. 78), vol. 1, p. 5.

88 Frel, 1982 edn. (see n. 55), p. 13: the arm was raised. Stewart (see n. 79), pp. 39, 200: neck lengthened by 1 cm, right arm dropped. In contrast, Viacava (see n. 55), p. 71: right arm was shifted and the neck lengthened during restoration.

89 For summary of the evidence and bib., see Mattusch (n. 16), pp. 206–16.

90 For the discovery of the late date of the Piombino Apollo, see Brunilde S. Ridgway, "The Bronze Apollo from Piombino in the Louvre," *Antike Plastik* 7 (1967): 43–75. For the twin, the Pompeii Apollo, which was excavated in 1977, see *Riscoprire Pompei*, exh. cat. (Rome, 1993), pp. 263–64, no. 193; and Mattusch (n. 16), pp. 139–40.

SELECTED BIBLIOGRAPHY

The following list includes a broad range of books intended for those who are interested in pursuing some of the subjects addressed in this book.

BOL, P. C.
Die Skulpturen des Schiffsfundes von Antikythera. Mitteilungen des Deutschen Archäologischen Instituts, Athenische Abteilung, Beiheft 2. Berlin, 1972.

BORN, HERMANN. ED.
Archäologische Bronzen: Antike Kunst, moderne Technik. Berlin, 1985.

EISEMAN, CYNTHIA JONES, and BRUNILDE S. RIDGWAY.
The Porticello Shipwreck: A Mediterranean Merchant Vessel of 415–385 B.C. College Station, TX, 1987.

FINN, DAVID, AND CAROLINE HOUSER.
Greek Monumental Bronze Sculpture. New York, 1983.

FREL, JIŘÍ.
The Getty Bronze. 1978. Rev. edn. Malibu, 1982.

HAYNES, DENYS.
The Technique of Greek Bronze Statuary. Mainz, 1992.

HEILMEYER, WOLF-DIETER.
Der Jüngling von Salamis: Technische Untersuchungen zu römischen Großbronzen. Mainz, 1996.

HELLENKEMPER SALIES, GISELA, ET AL. EDS.
Das Wrack: Der antike Schiffsfund von Mahdia. 2 vols. Cologne, 1994. [Articles by many scholars in English, French, and German.]

HYDE, WALTER WOODBURN.
Olympic Victor Monuments and Greek Athletic Art. Washington, D.C., 1921.

ISAGER, JACOB.
Pliny on Art and Society: The Elder Pliny's Chapters on the History of Art. New York, 1991.

MATTUSCH, CAROL C.
Classical Bronzes: The Art and Craft of Greek and Roman Statuary. Ithaca, NY, 1996.

MATTUSCH, CAROL C. ED.
The Fire of Hephaistos: Large Classical Bronzes from North American Collections. Exh. cat. Cambridge, MA, 1996.

MORENO, PAOLO. ED.
Lisippo: L'arte e la fortuna. Milan, 1995.

PLINY.
The Elder Pliny's Chapters on the History of Art. Trans. K. Jex-Blake. 1967. Reprint. Chicago, 1977.

POLLITT, J. J.
The Art of Ancient Greece: Sources and Documents. Cambridge, 1990.

POLLITT, J. J.
The Art of Rome: c. 753 B.C.–A.D. 337: Sources and Documents. 1966. Reprint. New York, 1995.

ROLLEY, CLAUDE.
Greek Bronzes. Trans. Roger Howell. London, 1986.

THROCKMORTON, PETER. ED.
The Sea Remembers: Shipwrecks and Archaeology. New York, 1987.

TRUE, MARION, AND JERRY PODANY. EDS.
Small Bronze Sculpture from the Ancient World. Papers Delivered at a Symposium Organized by the Departments of Antiquities and Antiquities Conservation and Held at the J. Paul Getty Museum March 16–19, 1989. Malibu, 1990.

SWADDLING, JUDITH.
The Ancient Olympic Games. London, 1980.

SWEET, WALDO E.
Sport and Recreation in Ancient Greece: A Sourcebook with Translations. New York, 1987.

VERMEULE, CORNELIUS C.
Greek Sculpture and Roman Taste: The Purpose and Setting of Graeco-Roman Art in Italy and the Greek Imperial East. Ann Arbor, 1977.

VIACAVA, ANTONIETTA.
L'atleta di Fano. Rome, 1994.

WEINBERG, GLADYS DAVIDSON, ET AL.
The Antikythera Shipwreck Reconsidered. Transactions of the American Philosophical Society. N.S. Vol. 55, part 3. Philadelphia, 1965.

ZIMMER, GERHARD.
Griechische Bronzegußwerkstätten. Mainz, 1990.

APPENDIX: MEASUREMENTS

Maximum preserved height: 151.5 cm

Diameter of head above ears: 17 cm

Diameter of head below ears: 12.5 cm

Maximum height of ear — right: 5.5 cm; *left*: 5.4 cm

Circumference of head above wreath: about 58 cm

Inner corner of eye to inner corner of other eye: 3.6 cm

Outer corner of eye to outer corner of other eye: 9 cm

Maximum width of eye — right: 2.7 cm; *left*: 2.8 cm

Maximum height of eye — right: 1.3 cm; *left*: 1.4 cm

Maximum width of mouth: 3.5 cm

Outer corner of eye to corner of mouth — right: 7.0 cm;
left: 7.2 cm

Minimum distance between right index finger and head:
less than 1 cm

Circumference of neck: 36.8 cm

Center of left nipple to center of right nipple: 23 cm

Circumference of chest across nipples: 92 cm

Left nipple to center of navel: 22.7 cm

Right nipple to center of navel: 24.1 cm

Circumference of torso at narrowest point: 74.7 cm

Maximum circumference of buttocks: 87.3 cm

Maximum length of penis: about 4 cm

Navel to top of pubic hair: 13 cm

Circumference of calf at widest point — right: 34.7 cm;
left: 35.4 cm

Elbow to point of wrist — right: 24.8 cm; *left*: 24.3 cm

Elbow to armpit — right: 28 cm; *left*: 23 cm

Circumference of wrist at bone — right: 18.4 cm;
left: 17 cm

ACKNOWLEDGMENTS

How could anyone have resisted reading newspaper reports about the Victorious Youth? I still have the stories about a "bronze and silver statue, a hero figure" (*The Daily American*, March 11–12, 1973), a work by Lysippos (*Salzburger Zeitung*, April 22, 1974), and a "barnacle-covered masterpiece" (*Saturday Review*, March 31, 1979). How could we have turned the page without reading those stories?

I am tremendously grateful to Marion True for asking me to write this book. I have learned a great deal while doing so, from her, from Richard S. Mason's ideas, as well as from the comments and criticisms of George L. Huxley, Sandra E. Knudsen, Harriet C. Mattusch, and John Papadopoulos, who all read the manuscript. I also thank the following interested and enthusiastic individuals: Catherine Atkinson; Elizabeth Bartman; Amy Brauer; Richard De Puma; A. A. Donohue; Edilberto Formigli; Nele Hackländer; Séan Augustine Hemingway; Marit R. Jentoft-Nilsen; Kenneth D. S. Lapatin; Jon Lash; Jeff Maish; Olga Palagia; Jerry Podany; Nancy H. Ramage; A. E. Raubitschek; Katherine A. Schwab; David Scott; Marie Svoboda; Despoina Tsiafakis; and Gerhard Zimmer. Benedicte Gilman's editorial contributions have been wonderful. I am grateful to the students in the Fall 1996 Greek Art class at George Mason University for their ideas and for their questions, all of which I hope to have addressed here, but only some of which we can so far answer.

Foldout

Statue of a Victorious Youth,
probably third–second
century B.C. Bronze with
copper inlays, height
151.5 cm (59⅝ in.).
Malibu, J. Paul Getty
Museum (77.AB.30).